IMAGES
*of America*

# PRIVATE CLUBS
# OF SEATTLE

IMAGES
*of America*

# PRIVATE CLUBS
# OF SEATTLE

Celeste Louise Smith and
Julie D. Pheasant-Albright

ARCADIA
PUBLISHING

Published by Arcadia Publishing
Charleston SC, Chicago IL, Portsmouth NH, San Francisco CA

Printed in the United States of America

Library of Congress Control Number: 2008938374

For all general information contact Arcadia Publishing at:
Telephone 843-853-2070
Fax 843-853-0044
E-mail sales@arcadiapublishing.com
For customer service and orders:
Toll-Free 1-888-313-2665

Visit us on the Internet at www.arcadiapublishing.com

*We would like to thank all the past members of the private clubs of Seattle for the legacy they have left us and the current members for their help and support. It is our devout wish that readers may find a club within these pages they may decide to join as a member and continue the traditions of the private clubs into this new century.*

# CONTENTS

# ACKNOWLEDGMENTS

This book would not have been possible without the kind assistance of many people. We would like to especially thank Bill Brady, who not only provided a treasury of photographs from the Arctic Club and College Club but was a font of information and interesting tidbits. Clinton White, collector par excellence, provided many photographs and historical research materials; this book could not have been possible without his help. Nicolette Bromberg, librarian, and Nancy Hines from the University of Washington Libraries Special Collections (UWLSC) are two of the unsung heroes of historical research in Seattle, as is Carolyn Marr of the Museum of History and Industry (MOHAI) and Jeff Ware from the Seattle Municipal Archives.

Elizabeth Buzzell McKenzie, Loveday Conquest, and Ken Tackitt all provided a treasury of photographs, for which we are most grateful. Mark M. Barron provided fascinating insights into the Arctic Club, as did Judy King and Sandra Boyd.

–Julie and Celeste

I wish I could thank my father, Robert Preston Pheasant, and his good friends Peter F. Gilmore and Bill Joost for all the wonderful times I had at all of the clubs around town they belonged to and for a lifelong appreciation of private club culture. I would also like to thank my mother, Helen Johnson Pheasant, for her insights into the University Club during the 1940s, and Elizabeth McAlpin McElhinney, Ed Wood, and Diana Sick Ingman for their wonderful stories.

—Julie

I would like to thank the board of trustees and past president Suzanne Price for allowing my use of the Women's University Club Archive for my research, as well as past president Lailla Petersen for her help in searching the archive for just the right photographs for that chapter. Many thanks go to the Woman's Century Club and Pres. Tammy Peterson for their unwavering support of this project.

I would like to thank my parents, Thor E. and Louise Smith, for all the special times we spent at the Arctic Club and my granddad Carl J. Smith, who understood that private club life was one of close friendships where lifelong memories are made. Finally, thanks to my grandmother Mrs. Carl J. Smith (Mary Jane), who in her lovely genteel way worked tirelessly in the Woman's Century Club and the Progressive Thought Club to bring women forward.

—Celeste

# INTRODUCTION

The private clubs of Seattle hold a unique place in Seattle's history, individually and collectively. The original nine private clubs were all organized in the hopes of promoting social connections, entertainment, business interests, sports, fraternity, and education in the new and thriving city. To understand the private clubs, one must first understand a little of Seattle's history. Between 1852, when the Denny party first stepped ashore at Alki Beach, and the coming of the railroads in the 1880s, the population had increased twelvefold. Fortunes were made in timber, salmon, lumber, real estate, and railways; scions of industry wanted a more private and exclusive place to socialize that resembled the clubs they knew on the East Coast more than the saloons of the early boom town. Names synonymous with the history and development of Seattle, like Judge Thomas Burke ("The Man Who Built Seattle"), railroad magnate J. R. McDonald, real estate barons James McNaught and John Leary, and other visionaries started the first club, the Rainier Club, in McNaught's mansion on Fourth Avenue. When the Great Seattle Fire decimated the Pioneer Square and downtown areas in 1889, it proved a boon for investors and property speculators, and the population boomed from 25,000 to 43,000.

The Great Seattle Fire started on First Avenue and Madison Street; what would become the private club buildings of Seattle were mostly built within a few blocks of each other, clustered between Second and Fourth Avenues and up to Boren Avenue, and Cherry and Madison Streets. Although each was formed for separate reasons, they had more in common with each other than they had differences. For starters, they often shared the same buildings. The College Club and the Women's University Club originally shared the same building (now the site of the Olympic Hotel), and it was proposed at one time that they share a connecting door. The Arctic Club and the Rainier Club both had homes in the original Arctic Building (now the Morrison Hotel) on separate occasions. But the common bond of the private clubs was more than real estate; it was philosophy.

The clubs were all formed to promote the interests of their members. The keynotes of the clubs at the dawn of the 20th century were privilege, exclusivity, and luxury, but each in its own way had a distinct personality. By 1925, there were 700 clubs listed in the Seattle phone book; we have chosen to include only these nine historic clubs. The most exclusive men's clubs were, and remain, the Rainier Club (founded in 1888) and the University Club (founded in 1900), which provided homes away from home for Seattle businessmen, mayors, and captains of industry. The Arctic Club was incorporated in 1908, but its roots went back further, to the Klondike gold rush of 1897 and the Alaska Club (founded in 1903). The Arctic Club was formed entirely to promote Alaskan business and provide a venue for men with business interests in Alaska to meet and socialize. The College Club's membership was limited to men who had college degrees when it was founded in 1910 and was designed to be the antithesis of the Rainier Club; it was intended to promote the same sort of fraternal feeling that members experienced during their college days.

The women's clubs were formed about the same time to provide an outlet for privileged women

to widen their knowledge through classes and good works in their community, allowing them social interaction with women of like interests. The Women's University Club (WUC), closely allied with the College Club and formed in 1910, and the Sunset Club, formed in 1913, provided a social outlet for women whose husbands were often to be found at the University Club. The Woman's Century Club (WCC) was more service oriented in aspect; founded in 1891 for the cultural and intellectual development of its members and for social service in the new century, the WCC embraced suffrage and social change in the developing city.

The Seattle Tennis Club and the Washington Athletic Club provided more of an athletic facet to the other amenities of private club culture, as well as being the only coed clubs. The original Seattle Tennis Club was founded in 1890 on Madison Street, a stone's throw from the other private clubs. The Washington Athletic Club (WAC) was built in 1930 to replace the old Seattle Athletic Club on Second Avenue and Cherry Street. Besides the clubrooms, restaurants, and bridge rooms of the other clubs, the WAC included a swimming pool, bowling alley, and gyms.

The most interesting aspect of private club culture in Seattle remains not in the buildings but in the members. Many Seattleites who belong to one private club belong to several; it is not at all unusual for members of one family to belong to the Tennis Club, the WUC, and the Rainier Club, all for different aspects of their services and amenities. Members of the various clubs have competed against each other for decades in bridge tournaments and squash games. Traditionally, men from the College Club and Rainier Club dated women from the Women's University Club, while University Club and Sunset Club members were often spouses.

One of the underlying philosophies of the clubs was a profound sense of social responsibility, an awareness of "noblesse oblige." Each participated in civic affairs, giving back to the city of Seattle and the nation. During World War I, the College Club formed a militia that trained and marched at the University of Washington; they sailed off to Europe as their own unit. World War II saw clubs like the WAC and the Rainier Club turning huge portions of their clubs to providing bandages and organizing activities supporting the troops.

While all the clubs maintained some level of exclusivity, the social changes of the 1960s brought changes to the private clubs. The first black member, first Asian, and the first female member were admitted to the College Club in 1968, which had been an all men's club. The Rainier Club followed suit in 1978. The private clubs' membership suffered a blow in 1984, when the IRS changed the tax laws to disallow deducting club memberships, but the private clubs as a group are still a viable force in Seattle. Many of the current club members are the grandchildren and great-grandchildren of the members who inaugurated these clubs 100 years ago or more.

Private club culture, once the bastion of old money and timber barons, has become a haven for learning, socializing, and dining, as well as making business connections. While the Arctic Club has been absorbed into the College Club (which has moved into temporary accommodation at the Columbia Tower Club), the once dwindling Woman's Century Club is on the upswing, and the WUC, Rainier Club, WAC, and Tennis Club are thriving. Although the University and Sunset Clubs' memberships are by invitation only, all of the other clubs are actively recruiting members.

The private clubs of Seattle, with their proud histories and their extraordinary buildings, are still a vibrant force in the social life of modern Seattle. We regret that space limitations have constrained our topics to the original nine clubs of Seattle built before World War II and that we have not included yacht or golf clubs, nor the fine modern clubs of Seattle. Within these pages, we hope you will enjoy learning about the clubs' histories and, if you are not yet a member, will consider the advantages, amenities, and camaraderie experienced at the private clubs.

# One

# THE ARCTIC CLUB

The Arctic Club incorporated in 1908, but its roots went back further, to the Klondike Gold Rush of 1897. On December 7, 1903, the Alaska Club was formed to promote Alaska and its resources and industry. In 1904, the 300 members of the Alaska Club moved to the Alaska Building on the corner of Second Avenue and Cherry Street. Located on the 15th floor, the Alaska Club contained a meeting room, reception room, and a large collection of Alaskan artifacts supplied by J. E. Standley, the proprietor of Ye Olde Curiosity Shoppe.

Soon it became apparent that the Alaska Club, which was largely commercial, needed more of a social aspect, and the Arctic Club was formed in April 1908. In 1909, the Arctic and Alaska Clubs merged. Instrumental in the formation were E. A. Von Hasslocher, formerly of Ketchikan, and A. D. Coulder, once a Chicago newspaperman. The first president was Falcon Joslin. Dues for life members were $300 before November 6, 1909, and $500 thereafter. Dues for resident members were $3 a month; nonresident members were charged $10 a year.

While the officers of the Arctic Club busied themselves with plans for the Alaska-Yukon-Pacific Exposition, the Arctic Construction Company, made up of investors from the Arctic Club, was working to complete the new club building on Third Avenue and Jefferson Street. By midsummer of 1909, the building was almost ready for occupancy when a warehouse fire destroyed most of the furnishings for the new club. Finally, on October 15, 1909, the new building was ready with reading, dining, and billiard rooms; a hall that served as library, buffet, and assembly room; and 120 sleeping rooms. On the day the club opened, the membership consisted of 198 life members, 667 resident members, and 300 nonresident members; a year later, membership would top 1,500.

By 1913, however, there was dissension between the Arctic Club and the Arctic Construction Company over the services and fees. After a lengthy negotiation, James Moses proposed the property at Third Avenue and Cherry Street, and the Arctic Building was built. With a lobby of Alaskan marble, distinctive walrus heads, and the fabulous wired-glass "Dome Room," the Arctic Club's new home was the social hub for Alaskan businessmen and prominent Seattleites. By the 1960s, however, the club building was sold, membership declined because of attrition, the rents were raised, and in 1971, the Arctic Club moved up the street to merge with the College Club at Fifth Avenue and Madison Street. It was the end of an era.

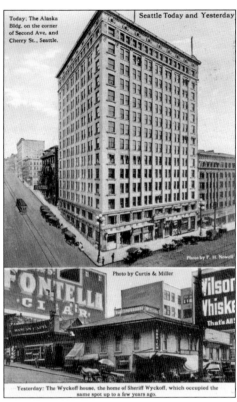

Seattle Today and Yesterday

Photo by F. H. Nowell

Photo by Curtis & Miller

Yesterday: The Wyckoff house, the home of Sheriff Wyckoff, which occupied the same spot up to a few years ago.

**ALASKA BUILDING.** The first steel-framed skyscraper in Seattle built after the Great Seattle Fire, the Alaska Building had a gold nugget embedded in the front door. Formed to promote Alaskan businesses, the club produced the annual *The Alaska Almanac* and was largely created to promote Alaskan business interests. This picture shows the "before" view of Sheriff Louis V. Wyckoff's house. (Courtesy UWLSC.)

**FUTURE SITE OF ARCTIC BUILDING.** This picture, taken in 1901 by Asahel Curtis, shows Prosper Casteran's French Hand Laundry (center) on Third Avenue, between Jefferson and James Streets, the future site of the first Arctic Club Building. (Courtesy UWLSC.)

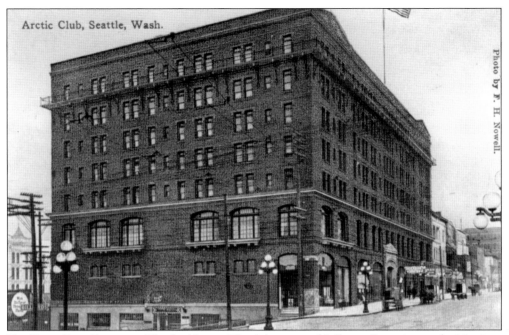

*Arctic Club, Seattle, Wash.*

*Photo by F. H. Nowell.*

**THE FIRST CLUB BUILDING.** This building at Third Avenue and Jefferson Street is now the Morrison Hotel. It contained 120 sleeping rooms, dining rooms, meeting rooms, and billiard rooms. The Arctic Club would only inhabit this building, built by the Arctic Construction Company, for four years. (Courtesy UWLSC.)

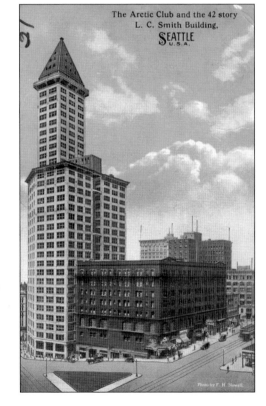

*The Arctic Club and the 42 story L. C. Smith Building.* SEATTLE U.S.A.

**ARCTIC CLUB AND SMITH TOWER.** The Smith Tower was opened on July 3, 1914; it was the tallest building west of the Mississippi until the Space Needle was built in 1962. At the time this picture was taken, the Arctic Club was still in the Morrison Hotel building and had not yet moved to the Arctic Building. (Courtesy Celeste Smith.)

11

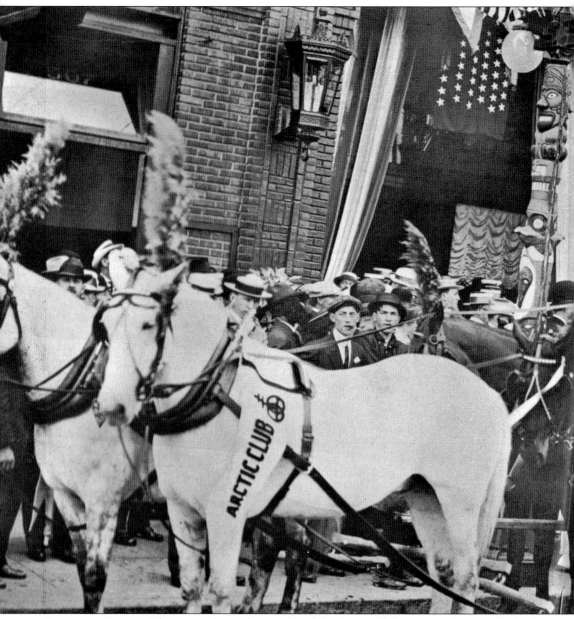

**POTLATCH PARADE.** This astonishing photograph of the Arctic Club entry in the 1912 Potlatch Parade was presented to the Arctic Club by charter (1910) life member William H. "Jack" Horner. The club members are dressed as Alaskan natives. The 1912 Potlatch was a summer celebration dreamt up by Joseph Blethen, eldest son of *Seattle Times* publisher Alden Blethen and the president of the Ad Club (which had organized specifically to work on the Potlatch), along with the *Post-Intelligencer* and the chamber of commerce. In the Seattle Potlatch myth, the five Alaskan tribal

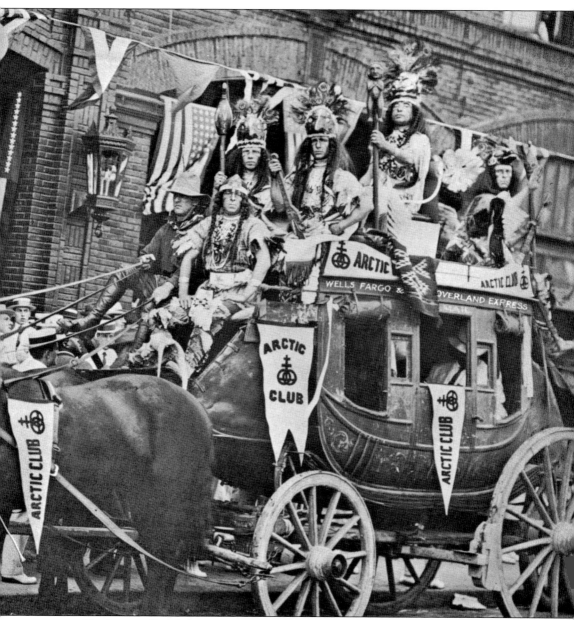

groups—all, of course, Seattle businessmen in costume—were responsible for constructing floats to lead the Great Potlatch Parade. This picture was taken in front of the Arctic Club Building on Third Avenue and Jefferson Street. Above the carriage, outside the frame of the photograph, is the sign for the Hotel Seward. Joe Blethen wrote the following ditty for the Potlatch: "Go and get a Puget sound on / That's the kind of noise to pound on— / Go and get a Puget sound on, / For the Potlatch Nine-teen-twelve." (Courtesy Arctic Club.)

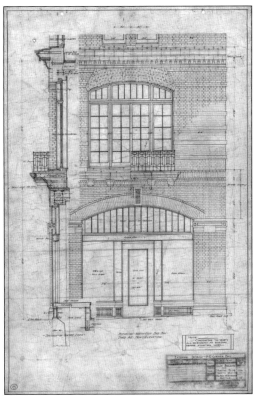

**ARCTIC CLUB BLUEPRINTS.** Designed by James H. Schack and Daniel R. Hinting, the first Arctic Club Building was built with reinforced concrete faced in brick. This view is of the details of the entrance. The building would be sold and become the Morrison Hotel. It once served as a temporary home to the Rainier Club. (Courtesy UWLSC.)

**AYPE ARCTIC CLUBHOUSE.** J. E. Chilberg, president of the Alaska Club, and William Sheffield, secretary, would become instrumental figures in the promotion of the 1909 Alaska-Yukon-Pacific Exposition (AYPE). Godfrey Chealander of Skagway, Alaska, proposed the idea in 1905, first to the Alaska Club and then the Seattle Chamber of Commerce. The idea grew, and on June 1, 1909, the Alaska-Yukon-Pacific Exposition opened to great fanfare, including the Arctic Club House seen here. (Courtesy Clinton White.)

# St. Andrew's Banquet

HELD UNDER AUSPICES OF
### THE CALEDONIAN SOCIETY, INC., OF SEATTLE

Arctic Club             Nov. 30, 1910

TOASTMASTER: MR. J. R. STIRRAT
CROUPIERS: MESSRS. MATTHEW DOW, JAS. FOWLER, ROBT. T. HODGE,
D. McKENZIE

**DINING ROOM PROGRAM.** This 1910 program of the Caledonian Society was typical of the kind of event the club sponsored. Not only could members sponsor dinners for organizations, they could sponsor resident guests (including staying in the sleeping rooms) for up to 15 days. Members of the army, navy, coast guard, Alaskan Road Commission, geological survey, and diplomatic corps who were not residents of Seattle could become temporary members for up to three months. (Courtesy author's collection.)

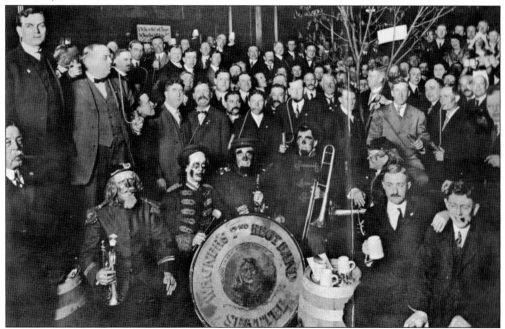

**THE SMOKER.** This picture was taken on April 26, 1912, and shows a typical smoker, which was a kind of stag party for men only. This smoker was probably held in conjunction with Seattle Potlatch festivities (Courtesy author's collection.).

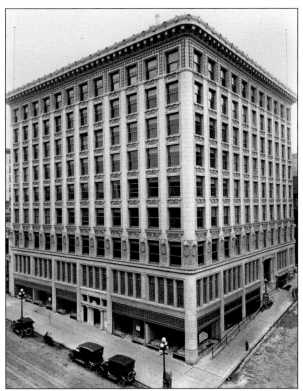

**ARCTIC CLUB BUILDING.** The new Arctic Club Building was designed by architect A. Warren Gould and included Alaskan marble in the hallways and walrus heads around the third floor. It was one of the first buildings to use terra-cotta panels over a steel-reinforced concrete frame. The building included a bowling alley and a roof garden, as well as meeting, sleeping, and dining rooms. (Courtesy MOHAI.)

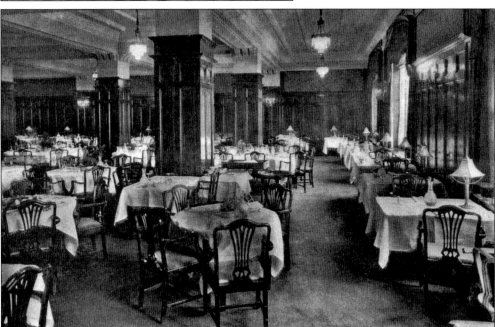

**MAIN DINING ROOM.** The only artifacts left from this dining room are the silver sugar bowls and a magnificent silver roast beef carving trolley, which moved with the Arctic Club to the College Club in the 1970s. The club also had private dining rooms, where residents could entertain guests. (Courtesy author's collection.)

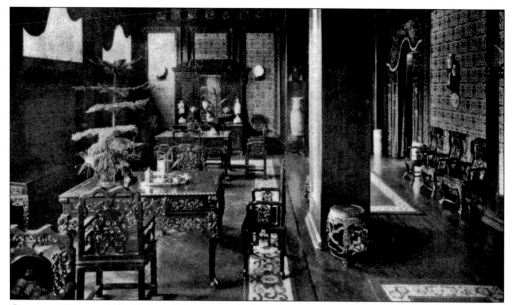

ORIENTAL ROOMS. The Oriental Rooms, including the tea room, were the "Ladies Rooms," open to women guests every day, including Sunday, from 3:00 to 8:00 p.m. The 1909 bylaws state, "Members are invited and requested to bring ladies to the special dinners given by the Club on Monday and Thursday evenings of each week . . . from 5:30 o'clock to 11 o'clock PM." Ladies were not allowed in any other rooms and were specifically disallowed from the billiard rooms. (Courtesy author's collection.)

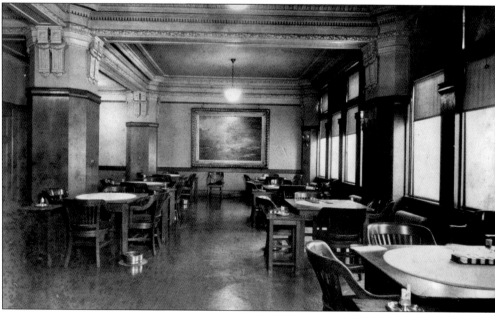

CARD ROOM. The Arctic Club was one of the four original clubs that competed for the Lipton Cup, and bridge and gin rummy were very popular. Sandra Boyd remembers that her father, William "Bill" Ferguson, was a member of what he and his friends called the Forty-Nine Club, which met to play cards on Mondays. They played for money until the FBI took offices in the building, which made them so nervous they moved their game to a hotel. (Courtesy College Club.)

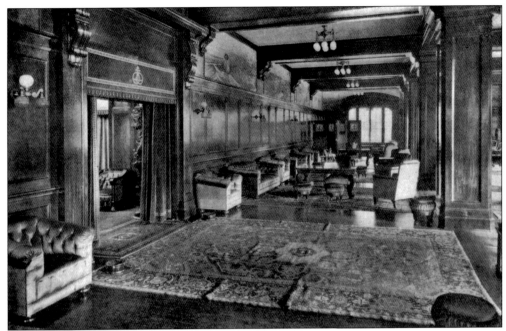

**ASSEMBLY ROOMS.** The Assembly Rooms were the heart of the club, where movers and shakers in Seattle and Alaskan business and politics conducted their business. Permanent honorary members included the present and former governors of Washington and Alaska, as well as those of British Columbia and the Yukon Territories. (Courtesy author's collection.)

**CORNER OF THE ASSEMBLY ROOM.** The Assembly Rooms were used for meetings, buffet dinners, cards, and dominoes, although the bylaws clearly state "no gambling games are permitted." The bylaws also state that "dogs are not permitted," which leads the reader to wonder if this was a recurring issue. Notice the Alaskan murals near the ceiling. (Courtesy author's collection.)

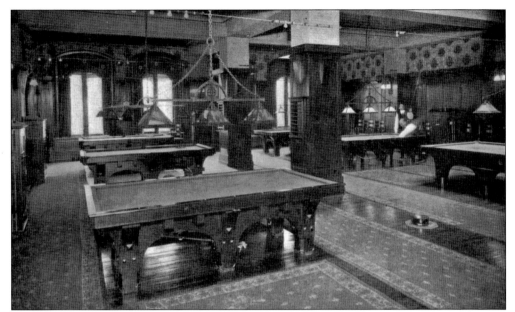

**BILLIARD ROOM.** The billiard tables from the first Arctic Club were moved to the Arctic Club Building at Third Avenue and Cherry Street and from there to the College Club at Fifth Avenue and Madison Street. It is hoped that the one remaining venerable table will make its next home at the new College Club. (Courtesy author's collection.)

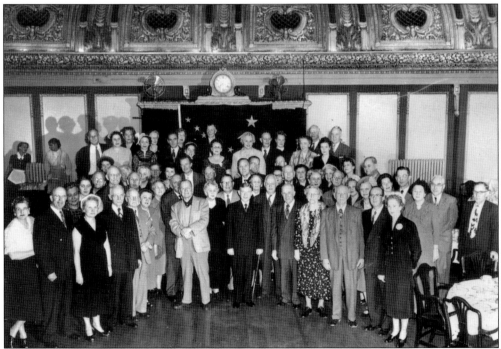

**FORMER RESIDENTS OF NOME.** This dinner at the Arctic Club on January 10, 1953, honored former residents of Nome, Alaska. Gold was discovered in Nome in 1898, and by 1900, there were 20,000 residents of Nome. By 1920, the boom town of Nome had shrunk to 820 residents. This picture, taken in the Dome Room, venerates those gold rush pioneers. (Courtesy UWLSC.)

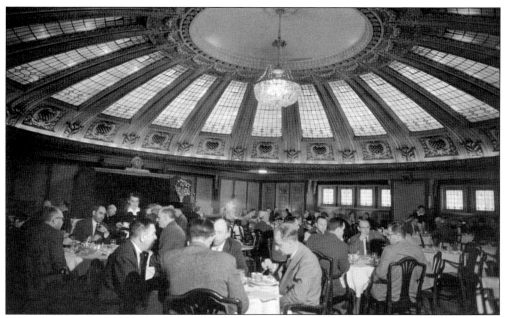

**DOME ROOM.** The famous Dome Room was the site of most club functions and is one of the Arctic Club's most iconic features. Until the 1960s, the glass was cleaned every three years. Sometime in the 1970s, the new owner of the Arctic Building replaced some of the wired glass with plastic. However, the Dome Room is again the site of elegant dining, resurrected as the Juno restaurant of the Arctic Hotel. (Courtesy author's collection.)

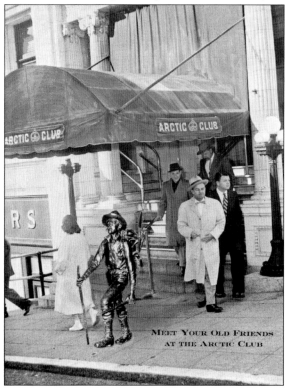

**ARCTIC CLUB ENTRANCE.** This picture was part of the Arctic Club's 50th anniversary book, published in 1958. The main focus of the club was Alaska and Alaskan business. The "sourdough" depicted was emblematic of the origins of the club in the Klondike gold rush. These men leaving the club in 1958 were typical of Arctic Club members, which included prominent Seattle and Alaskan businessmen, including Alaskan cannery owners like Alex Brindle and Alaskan shipping magnate Howard Skinner. (Courtesy author's collection.)

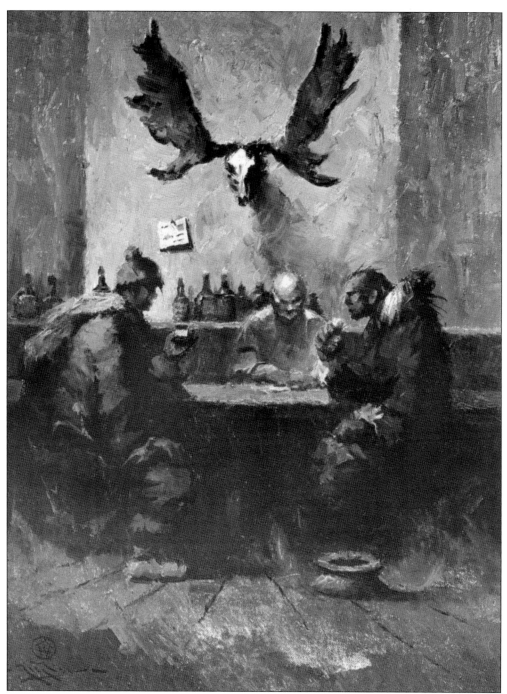

**Fifty Winters.** The famous Alaskan artist Eustace Paul Zeigler painted *Fifty Winters* for the Arctic Club's 50th anniversary in 1958. Originally he had planned to paint the men's bar but decided to paint two "sourdoughs" sharing a drink. Zeigler explained, "No, this is the Arctic Club—two men and a friendly glass. For fifty years of friendship, this is how I feel about the Arctic Club." Sadly, the picture was sold or given away after the merger with the College Club. (Courtesy author's collection.)

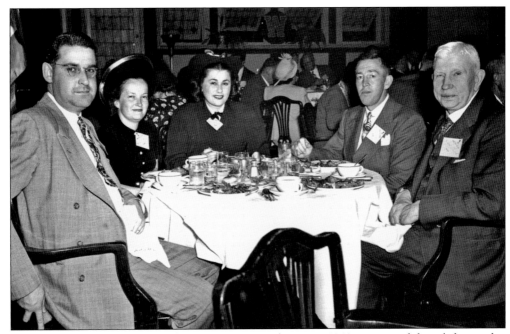

**DINNER IN THE DOME ROOM.** This group enjoying dinner in 1948 consists of, from left to right, coauthor Celeste Smith's father, Thor E. Smith; Mrs. Ernest Wilkes; Mrs. Thor Smith (Louise); Ernest Wilkes; and Judge Carl J. Smith, Esquire, one of the Arctic Club's charter members. The event was a University of Washington Sports Night. (Courtesy Celeste Smith.)

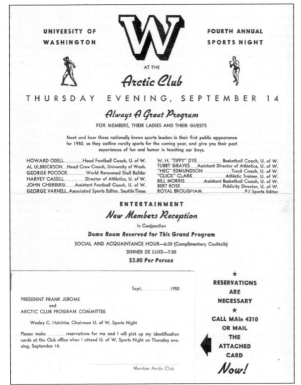

**ARCTIC CLUB SPORTS NIGHT.** The fourth annual University of Washington Sports Night at the Arctic Club featured sports legends Tubby Graves, George Pocock, Al Ulbrickson, Royal Brougham, and Clarence "Hec" Edmondson among others. This dinner, which included cocktails, was a real bargain at $3! (Courtesy Arctic Club.)

THE GRANDFATHER CLOCK. Thomas S. Nowell, an Alaskan pioneer and mining man, conducted a campaign to buy the grandfather clock when he lived at the old Morrison Hotel site. He collected $650 from fellow Arctic Club members in 1911 to buy the clock, which finally ended up at the College Club after the merger. This picture shows the cloakroom of the Arctic Club; the lobby and the clock cannot really be seen. (Courtesy author's collection.)

THE MEN'S BAR. The long wooden bar came from the Third Avenue and Cherry Street building. Despite talk of moving the bar, no agreement was made to procure it. The night before the opening of the new building, three prominent members simply got a horse and dray and, with the help of laborers, lowered the bar from the old building down to the alley and into the new building. The club ended up paying for it, and no one went to jail. (Courtesy author's collection.)

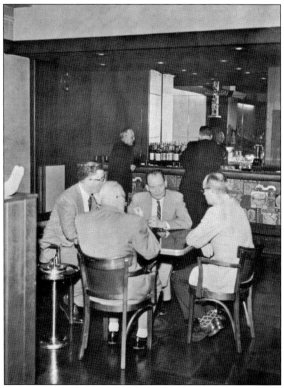

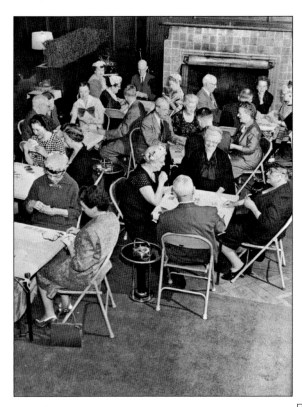

**BRIDGE ROOM.** The Arctic Club was one of the original four clubs in the Inter-Club Bridge League, which also included the Rainier, University, and College Clubs. The Arctic Club was the 1954 winner, with Daniel B. Trefethan as the chairman. The Arctic Club was the winner of four of the championships. (Courtesy author's collection.)

**MENU.** The emblem of the Arctic Club, called *Duo Juncti in Uno*, was designed to express a feeling of friendly unity and achievement. The two interlaced circles stand for the joining of two persons or bodies of men. The patriarchal cross represents trials or hardships. The red bar at the top of the cross represents these difficulties conquered. The horizontal bar joining the circles and cross represents unity. Sociability and pleasure are represented by the lower red bar. According to the 1958 Arctic Club 50th Anniversary book, the emblem "brings together men of the North and men of Seattle helping them towards success and friendship across the years." (Courtesy author's collection.)

Arctic Club
MENU
BUFFET LUNCHEON

.30
Clam Chowder

1.65
Shrimp Salad
Rolls
Coffee or Milk

1.60
Saratoga Lamb Roast-Mint Jelly
Potato and Vegetable
Coffee or Milk

1.65
Crab Salad, Ala Arctic
Rolls
Coffee or Milk

1.55
French Fried Filet of Sole-Tartar Sauce
Potato and Vegetable
Coffee or Milk

DESSERTS
Apple Pie .25          Pecan Pie .30

393 Cal.  HIGH PROTEIN SPECIAL     1.60
Baked Filet of Salmon-Lemon Wedge
Cole Slaw  Vinegared Beets
Coffee  Jello

**LADIES OF THE CLUB.** The authors remember that when ladies went to the club they had to enter a side door and were escorted to a room to wait. As if by magic, they were met by their party and escorted upstairs. Although the Arctic Club was a men-only club, the father-daughter dance was a real highlight for young ladies, as were the various events planned for the spouses of members. (Courtesy author's collection.)

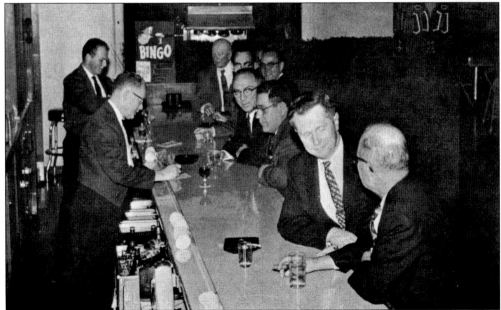

**THE BAR.** During Prohibition, the club was dry, but five bellhops in high-collared jackets vied for the privilege of delivering mixers to the upper rooms. One old-timer remembered that "whatever it was came straight off the boat in gunny sacks that were wringing wet, and a boy never got less than a dollar tip for bringing the mixer." The club was never raided, despite being across the street from the Prohibition administration headquarters. (Courtesy author's collection.)

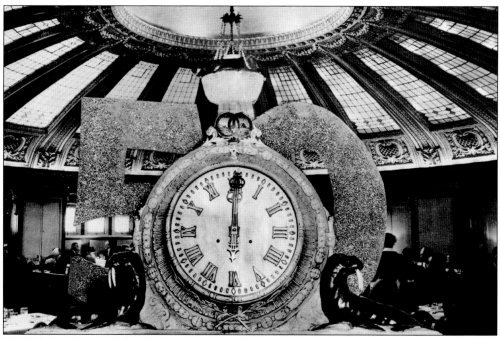

**THE WALRUS CLOCK.** This clock, commissioned for the 50th anniversary in 1958, was "donated" to the mayor of Seattle by the owner of the Arctic Building after the club moved to the College Club. Surviving members and descendants of the Arctic Club would like it back. (Courtesy author's collection.)

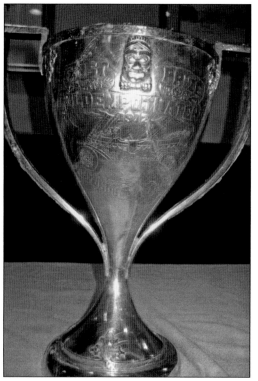

**ARCTIC CLUB TROPHY.** The Arctic Club won this trophy in the 1912 Seattle Potlatch Parade for the Best Car, seen on the previous pages. The small emblem is the Potlatch Bug logo. Joe Blethen wrote the following ditty, "The Bug," sung to the tune of "Yankee Doodle Dandy": "The Potlatch Bug's a fearful thing, / Beyond imagination. / When once it plants its venomed sting / It means inoculation. / The symptoms well are known to all / And so, too, what its bite is, / The aftermath, the doctors call / Enthusiasmitis. / There is no further use to fight / A prophylactic battle; / The Potlatch Bug is sure to bite / Each booster in Seattle." (Courtesy author's collection.)

# Two

# THE COLLEGE CLUB

In 1910, five Yale graduates sat around their boardinghouse in Ballard, picking slivers out of their hands and dreaming of life back east. Thomas Babcock, Ralph Angell, St. Clair Dickinson, Bob Forbes, and Bob Chase had come to Seattle to make their fortunes and got jobs in the timber mills in Ballard. Joined by Walter "Jack" Johnson, a University of Wisconsin graduate, they all moved into a house on Queen Anne Hill and dreamt of an inexpensive and democratic club to serve young men just graduating from college facing the problem of entering business or professions.

After several meetings, they had signed up 50 members and chose a president: Charles P. Spooner, a Princeton graduate with a law degree from Wisconsin, on the Board of Regents of the University of Washington. Spooner rented a suite of rooms on the second floor of the old federal court building on the corner of Fourth Avenue and Marion Street, across from the Rainier Club.

From the beginning, the sense of camaraderie and fellowship was high; attendance at daily lunches and special dinners was almost 100 percent. The club put on cabaret evenings, the annual Christmas Wassail dinner, and Thanksgiving Hi-Jinks and formed an Outing Club, which had a lodge at Roaring Creek. World War I saw more than half of the club members go off to war; the club suspended their dues for the duration.

Soon the club outgrew their rooms, and the Metropolitan Building Company built them a building on the corner of Fifth Avenue and Seneca Street, which they shared with the Women's University Club from July 5, 1912, until December 17, 1921. Once again the College Club had outgrown their space; a new building was erected on Sixth Avenue and Spring Street and dedicated on December 21, 1921. The club was renovated in 1951 and 1952, but by then, it was evident that the I-5 freeway was going to be built through the middle of downtown. The club purchased the lot at 505 Madison Street for $100,000 in 1954, and the old clubhouse was torn down in 1962.

The club enjoyed its headquarters at 505 Madison Street, until it became apparent the building was in need of repair, and it was more economical to sell the property and look for a new home. As of 2008, the club is now in temporary quarters at the Columbia Tower Club and will no doubt be looking for their new home soon.

**METROPOLITAN BUILDING.** The Metropolitan Building was the second home of the College Club; the first was a suite of rooms in the federal court building. The Metropolitan Company was very generous to the College Club; they paid for furniture and equipment, which the young club could not afford to buy. (Courtesy College Club.)

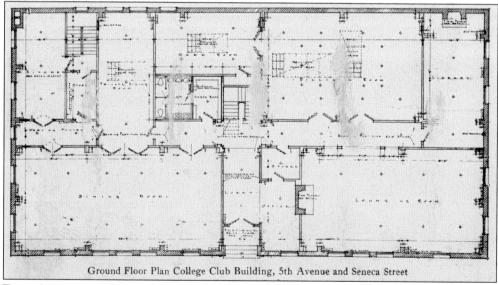

Ground Floor Plan College Club Building, 5th Avenue and Seneca Street

**FIFTH AVENUE AND SENECA STREET BLUEPRINTS.** The Fifth Avenue and Seneca Street building shared a common wall with the Women's University Club. It was suggested at one point that a connecting door be built; that motion was shot down by the male members of the College Club. (Courtesy College Club.)

**THE WAR.** A series of programs were held in 1915 to discuss the war, including a program by Antarctic hero Sir Ernest Henry Shackleton. By 1916, a militia of 100 civilian members marched in a patriotic parade, and a militia under Capt. A. H. Beebe trained with rifles at the University of Washington. The club participated in Red Cross drives, Liberty Loan drives, and Wheatless and Meatless Days, and the club suspended the dues of all men in the services. (Courtesy College Club.)

# War Party

Saturday Night, March 13, 1915
[Dinner at Six: Address at Eight]

❧ THIS will be the first of a series of Saturday night meetings devoted to serious consideration of the big war. In other words—HIGHBROW STUFF.

## John C. Higgins

who has made an exhaustive study of the subject will deliver the address, his subject being:

"The Responsibility for the European war, from the Standpoint of England and her Allies."

❧ ON Saturday week—March 20—Dr. Conrad A. Tressman of the University of Washington German Department, who was in Germany at the outbreak of the war, will talk for the German side. It is probable that a third Saturday night will be devoted to general discussion.

PLAN TO ATTEND THE WHOLE SERIES
Bring a guest—He'll enjoy it

Dinner at Six          Eats at Ten-Thirty
Fifty Cents            They're Free

## College Club *of* Seattle

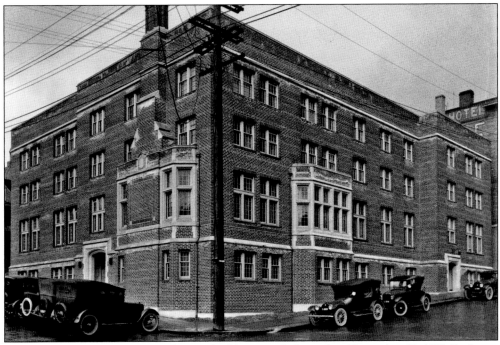

**SIXTH AND SPRING BUILDING.** The new building was dedicated on December 21, 1921. Built at a cost of $200,000, its architects were College Club members Harlan Thomas and David J. Myers. According to members, this building is now at "Sixth and Oblivion," as it was torn down in 1962 to make way for the freeway. (Courtesy MOHAI.)

**COLLEGE CLUB CABARET.** This event was held at the Olympic Hotel, oddly, the very site of the previous College Club building. College Club Cabaret nights were very well attended during the 1910s and Roaring Twenties. Jimi Hendrix played at the College Club in the early 1960s; the hospital across the street called the police to complain about the noise. The police came and found the noise within reason. (Courtesy College Club.)

**CABARET.** The lure of the footlights, the smell of the greasepaint, and the roar of the crowd has proved irresistible to College Club members for generations. This 1914 production of *Tango Town* shows the "Chorus of Huzzars." All parts of the production were by club members, including "Heidelberg Students, Spanish Soldiers, Show Girls, and Ponies." From left to right are Carl Ballard, Donald Campbell, Arthur Schramm, Louis Cosgrove, Fred Dorr, Alfred H. Lundin, Dr. Carl DeMille, and H. G. Sibbs. (Courtesy College Club.)

30

**SMOKER, 1929.** The College Club Smoker was an annual male-only event featuring boxing and usually some sort of vaudeville or burlesque acts. (Courtesy College Club.)

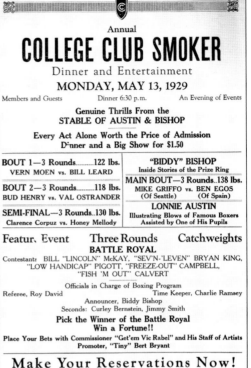

Annual

# COLLEGE CLUB SMOKER

Dinner and Entertainment

### MONDAY, MAY 13, 1929

Members and Guests                 Dinner 6:30 p.m.                 An Evening of Events

Genuine Thrills From the
**STABLE OF AUSTIN & BISHOP**

Every Act Alone Worth the Price of Admission
D:nner and a Big Show for $1.50

| | |
|---|---|
| BOUT 1—3 Rounds..........122 lbs.<br>VERN MOEN vs. BILL LEARD | **"BIDDY" BISHOP**<br>Inside Stories of the Prize Ring |
| | MAIN BOUT—3 Rounds..138 lbs. |
| BOUT 2—3 Rounds..........118 lbs.<br>BUD HENRY vs. VAL OSTRANDER | MIKE GRIFFO vs. BEN EGOS<br>(Of Seattle)       (Of Spain) |
| | **LONNIE AUSTIN** |
| SEMI-FINAL—3 Rounds..130 lbs.<br>Clarence Corpuz vs. Honey Mellody | Illustrating Blows of Famous Boxers<br>Assisted by One of His Pupils |

Featur. Event     Three Rounds     Catchweights
**BATTLE ROYAL**

Contestants  BILL "LINCOLN" McKAY, "SEV'N-'LEVEN" BRYAN KING,
"LOW HANDICAP" PIGOTT, "FREEZE-OUT" CAMPBELL,
"FISH 'M OUT" CALVERT

Officials in Charge of Boxing Program
Referee, Roy David                                Time Keeper, Charlie Ramsey
Announcer, Biddy Bishop
Seconds: Curley Bernstein, Jimmy Smith

**Pick the Winner of the Battle Royal
Win a Fortune!!**

Place Your Bets with Commissioner "Get'em Vic Rabel" and His Staff of Artists
Promoter, "Tiny" Bert Bryant

## Make Your Reservations Now!

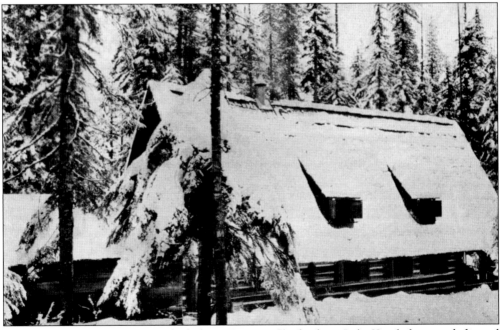

**THE MOUNTAIN GOAT LODGE.** The lodge at Roaring Creek, above Lake Keechelus, was dedicated on July 10, 1915; Dr. Henry Suzzalo, president of the University of Washington, was on hand for the festivities. The Outing Club, led by Albert Beebe, built the lodge, although it was open to all club members. The lodge was later sold. (Courtesy Clinton White.)

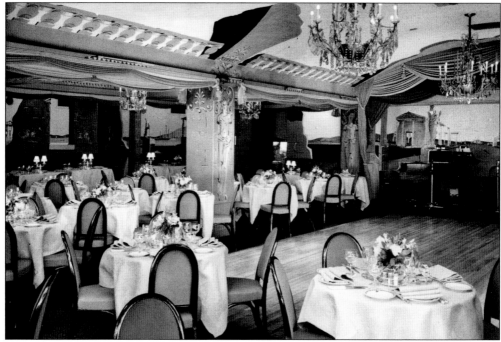

**THE DINING ROOM.** This elegant dining room at the Sixth Avenue and Seneca Street building was the scene of countless dinners, luncheons, and musical evenings. The beauty of this room rivaled any private club dining room in town. (Courtesy College Club.)

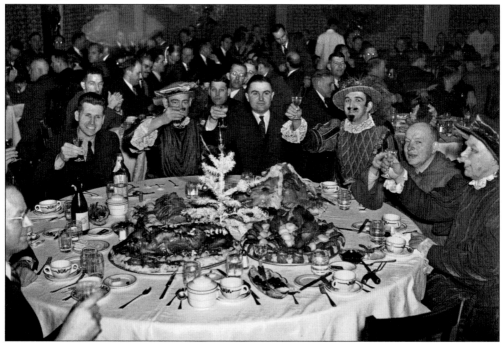

**CHRISTMAS PARTY, 1939.** The Annual Christmas Party and Wassail Bowl play, with its revival of what the College Club book for members calls the "Old English Yuletide Customs," have been a College Club tradition since its 1925 inception. (Courtesy MOHAI.)

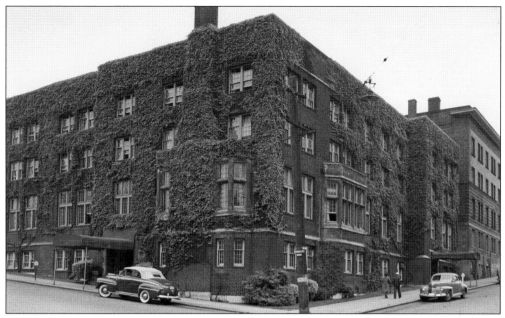

**COLLEGE CLUB, 1948.** This picture shows the club as it was in 1948. Despite a considerable rate of attrition by members during the Depression and the Second World War, the club survived. World War II was especially difficult, as the Japanese employees of the club were interned, and rations were hard to come by. However, the club met some of its mortgage obligations by installing "one-armed bandits;" the mortgage was paid off on May 14, 1945. (Courtesy College Club.)

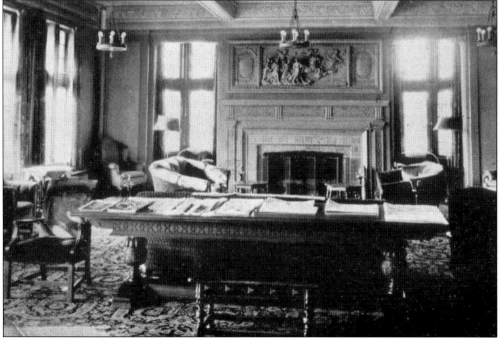

**NORTH END CLUB LOUNGE.** The north end of the lounge featured a large fireplace and a selection of papers. The club's library (out of the frame) was one of the finest in the city thanks to the diligent labor of William Bolen. (Courtesy Clinton White.)

33

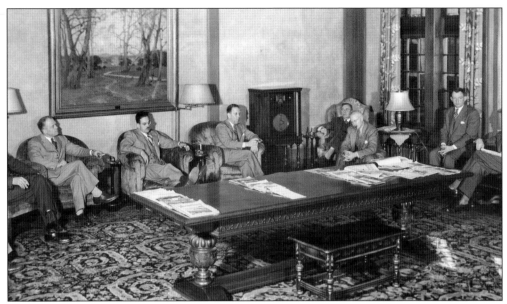

**THE GROVE PAINTING.** The painting, which graced the College Club for 80 years, was presented by member C. A. Black in 1922. *The Grove* was painted by William Wendt in 1915 and depicted a scene in Hot Springs Canyon, near San Juan Capistrano. It was first hung at the Winter Exhibition of 1915 in the National Academy, New York City, then in 1916 at the Philadelphia Academy, and was shown in museums in Detroit, St. Louis, and Chicago. In 1917, the painting was shown at the California Art Club Spring Exhibition, where it won the Clarence A. Black prize of $100. (William Wendt was on the board of directors of the Art Club and the hanging jury!) This wonderful painting hung in both club locations; eventually the painting became too valuable to insure and was sold. The cabinet in the background is still part of the College Club furniture. (Both courtesy College Club.)

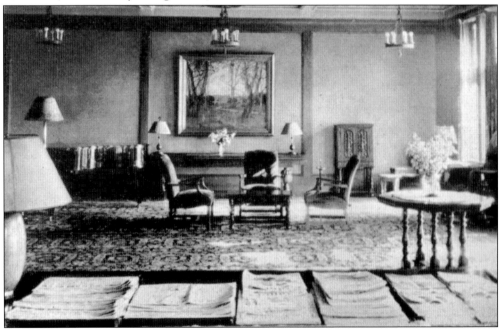

**DANCE.** Judging by the hairstyles and the dresses, this appears to be a prom in the late 1940s or early 1950s in the building on Sixth Avenue. The College Club has always been a popular venue for proms and wedding receptions. (Coauthor Julie D. Pheasant-Albright had her own wedding reception at the College Club, as well as her birthday party.) For many years, events had to be sponsored by members; recently the club has relaxed that rule. This same group is seen enjoying dinner at the club; the College Club has always prided itself on its fare and fair prices. The College Club was traditionally a club for young men right out of college entering business or professions. (Both courtesy College Club.)

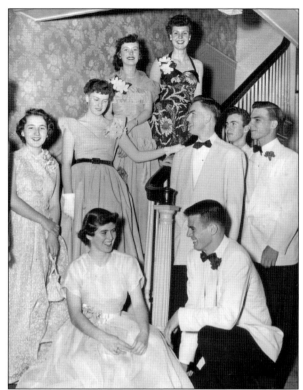

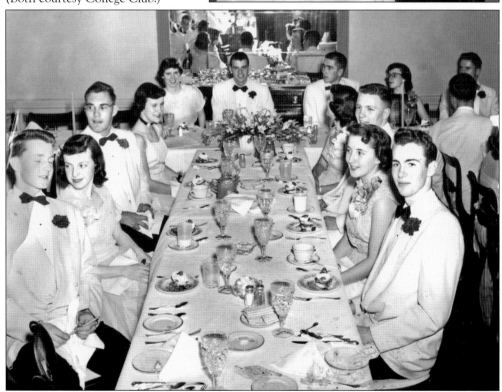

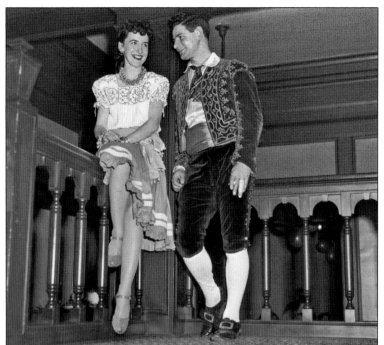

**HALLOWEEN.** Kathleen Scavato and Dick De Donato are enjoying a moment away from the festivities in the College Club. In recent years, a Cinco De Mayo Party has been held at the club; this couple would fit right in. Notice that Dick has a broken finger, perhaps from playing squash? (Courtesy MOHAI.)

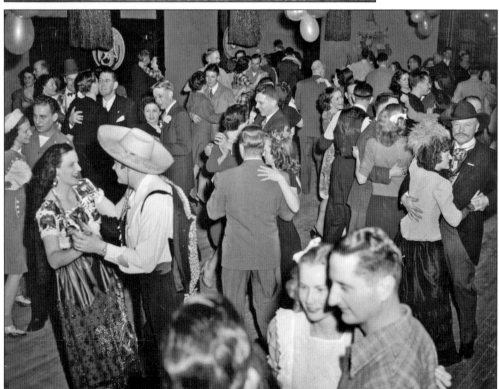

**HALLOWEEN PARTY.** Judging by the suits, this Halloween party took place in the 1940s. The identities of the Bavarian couple, the sailors, and farmhands are unknown, but this party was a College Club tradition for many years. (Courtesy MOHAI.)

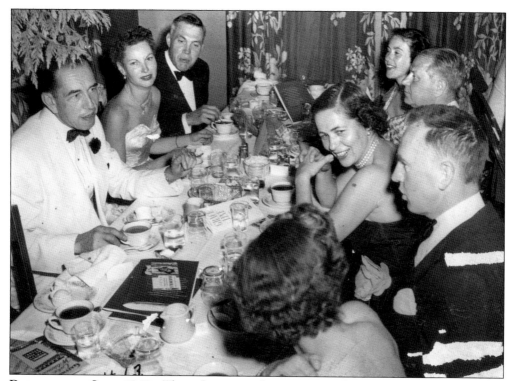

DINNER AT THE CLUB, 1940s. These elegant couples are enjoying dinner at the club; the brochures on the table are for Hawaii and Lake Wilderness. The dress codes were somewhat relaxed in recent years, although "proper sports attire" (as opposed to a jacket and tie) is still only acceptable in the bar and Card Room. (Courtesy College Club.)

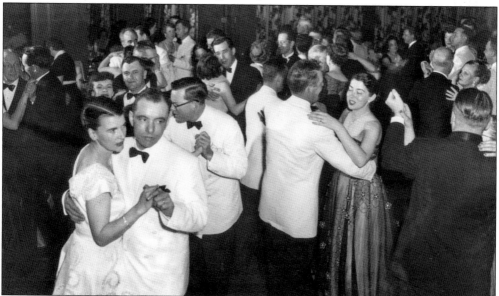

DANCE AT THE CLUB. These couples are enjoying a dance at the College Club in the 1950s. It must have been summer because of the many gentlemen wearing white dinner jackets, as opposed to the usual black. (Courtesy College Club.)

**Basketball Champions.** These young men with their fathers were the 1954 basketball champions who played other clubs and teams within the city. The College Club has always been very sports oriented and has provided members with tickets to sporting events, as well as meals beforehand. (Courtesy College Club.)

**Roaring Twenties Night.** These club members are enjoying the annual Roaring Twenties Night. The average club member was in his 30s; the College Club was specifically formed for young men just out of college to re-create the fun and camaraderie of their college days. When the club was incorporated in 1910, the unstated purpose was to be the antithesis of the Rainier Club, which the young College Club founders in their 20s found a bit too stuffy. To that end, the club has always been very sports oriented, with an Outing Club, fishing trips, hiking trips, and Husky football parties. (Courtesy College Club.)

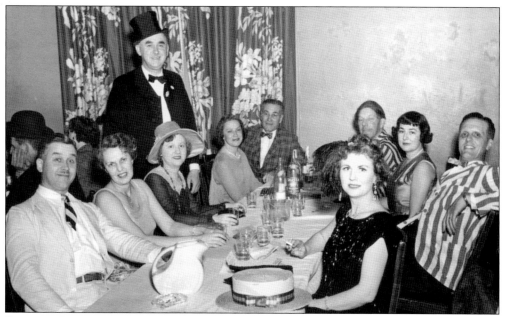

ROARING TWENTIES NIGHT DINNER. This unidentified group of diners at Roaring Twenties Night at the College Club shows off a wide variety of authentic 1920s clothing, from top hats and derbies to cloches and straw boaters, all typical of the time. This group probably raided their parents' attics for the attire. This picture had to be taken after the repeal of Prohibition; note the bottles on the table. (Courtesy College Club.)

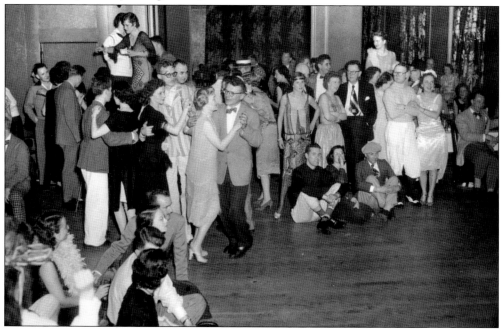

ROARING TWENTIES NIGHT DANCE. In the grand tradition of the Roaring Twenties, some club members seem to be dancing on the tables. The beaded gown on the woman in the center would likely be an authentic 1920s flapper beaded chemise; in 1955, the dress was most likely the lady's mother's gown. (Courtesy College Club.)

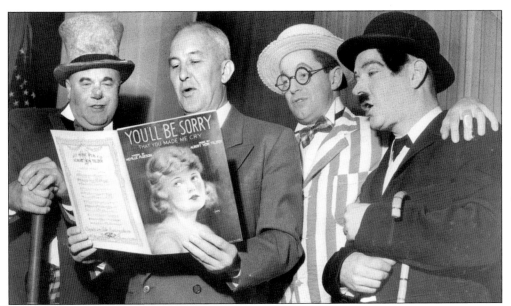

**YOU'LL BE SORRY.** These gentlemen are singing a song written in 1921: "You'll Be Sorry (that you made me cry);" music was by Albert Von Tilzer, words by Neville Fleeson: "You'll be sorry you made me cry / I'm feelin' so blue, don't know what to do / *Chorus:* You'll be sorry that you made me cry / you'll be sorry that you said goodbye." (Courtesy College Club.)

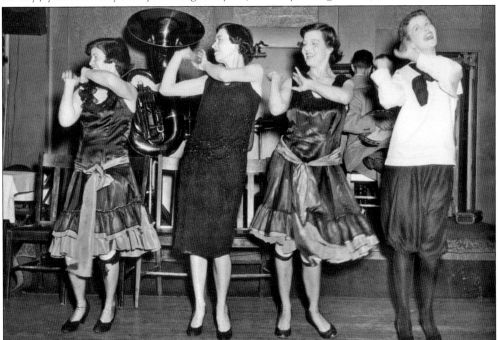

**ROARING TWENTIES.** These young ladies show off their Charleston skills at the College Club. The dance was based on a tune called "The Charleston" by composer/pianist James P. Johnson that originated in the Broadway show *Runnin' Wild* and became one of the most popular hits of the decade. The young lady's middy blouse and the rolled stockings were as typical of actual 1920s dress as the better known flapper dress. (Courtesy College Club.)

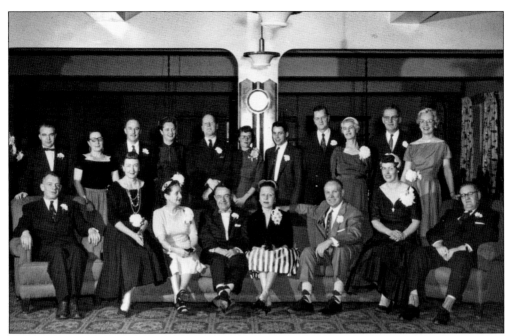

**PRESIDENT'S NIGHT DINNER.** Judging by the hats and the Mamie Eisenhower bangs, this group was photographed in the 1950s. The Wednesday before the annual meeting, guests of the outgoing president, as well as all the past presidents, the board of trustees, nominees to the board, and chairs of committees are served a formal gourmet dinner. (Courtesy College Club.)

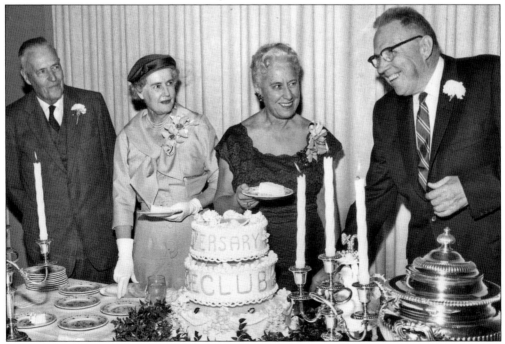

**ANNIVERSARY.** The cake topper seems to indicate that this is an anniversary party rather than a wedding. The College Club has always been a popular venue for weddings and private parties, from small intimate functions to large weddings. (Courtesy College Club.)

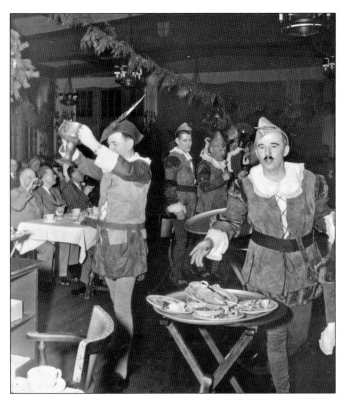

**WASSAIL.** The Wassail Party has been an annual event at the College Club since 1925. Club members, as well as employees, traditionally dress up in what the members book refers to as "Olde English" costumes and serve the guests. These gentlemen in the Sixth Avenue building seem to be dressed as Robin Hood's merry men. (Courtesy College Club.)

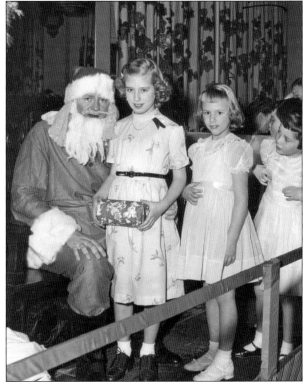

**SANTA AT THE COLLEGE CLUB.** The club has traditionally held a Children's Christmas Lunch. The identities of these three adorable young ladies meeting Santa are unknown, but the picture seems to have been taken in the 1950s. (Courtesy College Club.)

CHRISTMAS. This couple and their daughter are waiting for Santa at the annual Children's Christmas Lunch. The chair is recognizable to current College Club members, as it was part of a set that resided in the hall at 505 Madison Street. (Courtesy College Club.)

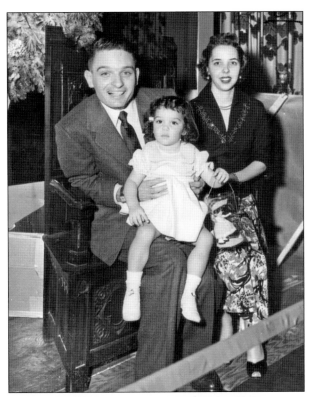

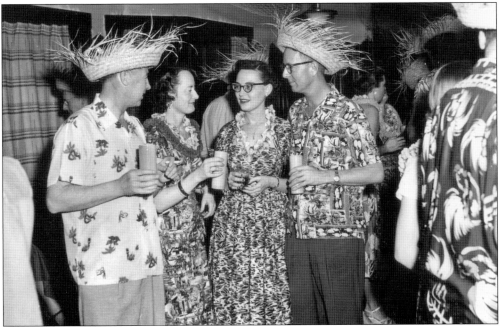

LUAU, 1950s. The Luau was an annual event for many years, allowing soggy Seattleites to get a taste of the tropics. Launched after World War II, the "tiki culture" of Trader Vic's was popular in Seattle, as evidenced by the Trader Vic's restaurant and bar, which opened in Seattle in 1948. (Courtesy College Club.)

**LADIES TEA.** The College Club held an annual Ladies' Tea at Christmas, usually in conjunction with a fashion show. In 1968, the College Club was the first private male-only club in Seattle to initiate female members. Until that time, ladies had to enter through the ladies entrance on Sixth Avenue to the Ladies Department and sign in. However, members not accompanied by ladies or children could not enter the "Ladies' Department." (Courtesy College Club.)

**CLUB ENTRANCE BURNS NIGHT.** The new club at 505 Madison Street was the scene of the Caledonian and St. Andrews Society Burns Night Dinner on January 25. Here we see the group parading in the Haggis. The Caledonian Society celebrated its 1910 Burns night at the Arctic Club, which merged with the College Club. The club has also been the setting for many Friends of St. Patrick dinners on March 17. (Courtesy College Club.)

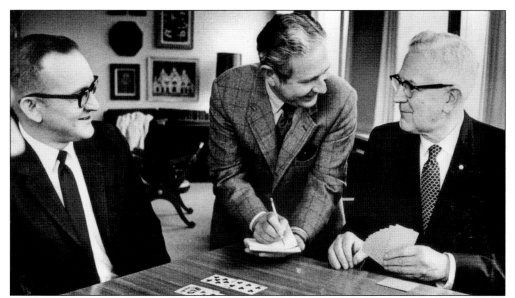

**BRIDGE.** Bridge has always been an important part of College Club history, as the club was one of the original four clubs competing for the Lipton Cup; the tournament has been held since 1915, with the exception of the war years. While he was stationed at Fort Lewis prior to World War II, Dwight Eisenhower played bridge at the College Club with past club president Gen. A. H. Beebe. (Courtesy College Club.)

**SEAFAIR.** The first SeaFair Dance was organized by Hans Christianson and held in August 1950. The dance was a College Club tradition for many years; the SeaFair princesses in attendance proved a big draw for the bachelors of the College Club. (Courtesy College Club.)

**DINING ROOM.** The dining room used to be so full that they took reservations, and lines formed out into the hallway. This picture looks much like it did when author Julie D. Pheasant-Albright went to lunch on her 21st birthday; her father, Robert Pheasant, is seated center at the third table from the front. At the time this picture was taken, the dining room had an unobstructed view of Puget Sound. (Courtesy College Club.)

**SQUASH PLAYERS.** Squash has always been an important part of College Club culture since the squash courts were built on to the Sixth Avenue and Seneca Street building in 1934 for $5,000. The College Club is one of many league squash clubs, as is the Washington Athletic Club. This picture was taken at the 505 Madison Street building. (Courtesy College Club.)

46

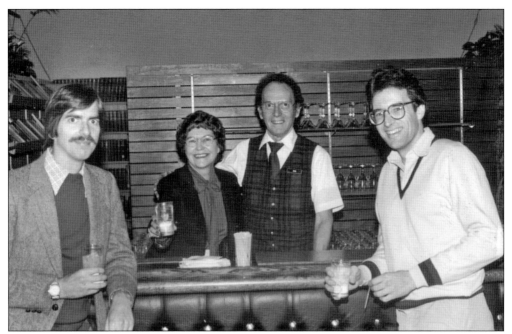

**SQUASH PLAYERS IN THE LIBRARY.** Seen here is Bruce Howley (far left) with an unidentified group of people in the library bar after a championship squash game. Squash is popular because a rousing game can be played in a lunch hour. For many years, members of the famous Khan family taught and coached at the College Club. (Courtesy College Club.)

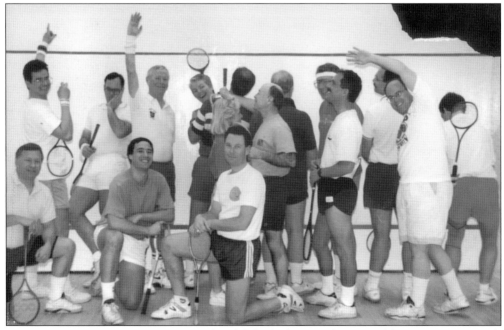

**SQUASH PLAYERS WITH PRIZES.** Since the club built the squash court addition in 1934, squash has been an important club activity. Round Robin play on Monday nights, novice tournaments, and the annual Inter-Club Tournament in the spring have always attracted members. This group shows off their prizes from an Inter-Club Tournament. (Courtesy College Club.)

**ALOHA FROM SEATTLE.** This group at a Luau stands in front of the grandfather clock from the Arctic Club. The clock was bought by a group of Arctic Club members, spearheaded by Thomas Nowell, in 1911 for the princely sum of $650. (Courtesy College Club.)

**LUAU.** The Luau was an annual event; this picture was taken in the library downstairs at the 505 Madison Street site. Just out of the picture to the left is the College Club's grand piano. (Courtesy College Club.)

**OUR VALUED EMPLOYEES.** Luke Sosler, dining room manager, and Kimberly Martin were only two of the wonderful College Club employees who made members' lives easier. (Courtesy author's collection.)

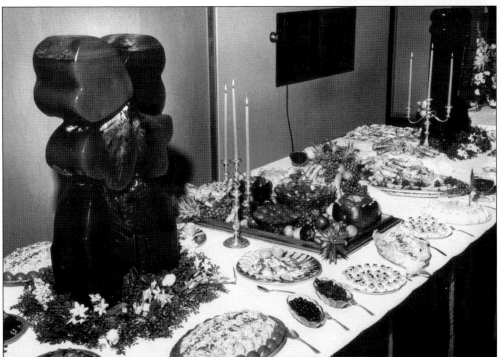

**VALENTINE'S DAY.** Valentine's Day was another important club function, along with Easter brunch, Mother's Day brunch, the Christmas party, Wassail Bowl Dinner, Husky football brunch, the Crab Dinner, elegant bimonthly gourmet dinners, and casino nights. (Courtesy College Club.)

**PRES. TOM ALLEN.** Tom Allen, the 2008 College Club president, had the challenging job of supervising the club at their temporary Columbia Tower home while looking for the club's new home. He and his wife, Anne, are seen here at the last dinner held at 505 Madison Street. (Courtesy author's collection.)

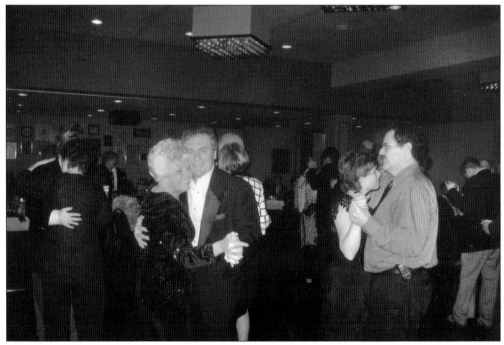

**THE LAST DANCE.** Past president Jack Gunnar is dancing with assistant manager Mary Pat Bonus at the last dinner gala. Mary Pat has been a mainstay of the club, arranging football tickets and events for members. (Courtesy author's collection.)

**CLUB MANAGER.** Peter Sparling has been the face of the College Club for many years and has been not only the manager but active in the fishing outings the club has put on over the years. (Courtesy author's collection.)

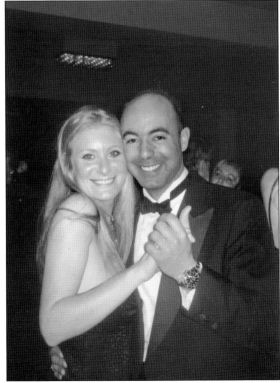

**PAST PRESIDENT.** Randy Petgrave III had the unenviable job of steering the club while the decision to make a change in club facilities was made. He and Chavell Gunner are seen at The Celebration dinner on February 2, 2008, the last formal occasion at the 505 Madison Street building. (Courtesy author's collection.)

**BILL JOOST.** Bill Joost was a longtime College Club member who could be encountered almost every day eating lunch in the bar. Sadly, Bill died in 2006, and his memorial service was held at the club. In this picture, Bill, chairman of the Varsity Boat Club Dance, was showing the Poughkeepsie Cup to two University of Washington coeds. Bill is sorely missed. (Courtesy UWLSC.)

**CLUB SIGN, 505 MADISON.** This ditty was composed by Evan R. Peters for the silver anniversary of the College Club in 1935: "Those who have known / The joys of college days, / The happy hours whose memories are so dear. / And seek the fellowship of kindred hearts— / Look for this sign, and, / Entering, find it here." (Courtesy author's collection.)

# *Three*

# THE RAINIER CLUB

In 2008, the Rainier Club celebrated its 120th year in Seattle. Founded in 1888, it is one of the city's most beloved clubs. The original idea for the club came from William Allison Peters and Judge Thomas Burke, who felt the city needed a private club for Seattle's business and professional men. The idea caught on, and the first meeting was held on February 23, 1888, with Bailey Gatzert (the first Jewish mayor in Seattle), J. R. McDonald, John Leary, Norman Kelly, R. C. Washburn, and A. B. Stewart in the 22-room McNaught mansion. James McNaught was present when W. A. Peters was elected the club's first president. Peters went on to become president of the University Club in 1909.

The name was chosen by the organizers of the club to honor a British admiral named Peter Rainier. The founders then needed a place to meet, and with McNaught moving to take a position with the Northern Pacific Railroad as chief counsel in St. Paul, it was a perfect opportunity to rent the mansion to the Rainier Club for the sum of $100 a month.

On June 6, 1889, catastrophe struck, and the Great Seattle Fire burned down almost all of downtown Seattle and Pioneer Square; however, the McNaught mansion survived. By 1890, its members were getting anxious to relocate. On May 10, 1892, members were convinced by the board to move to the Seattle Theater building, which is now the present site of the Arctic Club Building.

In 1903, with the club growing out of its present building, they leased two lots on the corner of Fourth Avenue and Marion Street. The architect Kirtland K. Cutter was retained, and at a cost of $85,000, the club was completed. In this new building, the club included resident rooms for members and guests. One of the most fascinating resident members was photographer Edward Curtis. When the club was remodeled, they found boxes of Curtis' autographed books stuffed into the ceiling.

During World War I, the Rainier Club bought $11,000 worth of war bonds and sent an ambulance to France. During World War II, the club rescinded their policy and allowed the Norwegian Relief Fund and Bundles for Britain charities to use the facilities, and a victory garden was grown on the south lawn.

A club that was conceived in 1888 in the minds of a few men, and had certainly had its struggles to continue, remains today one of Seattle's most cherished institutions.

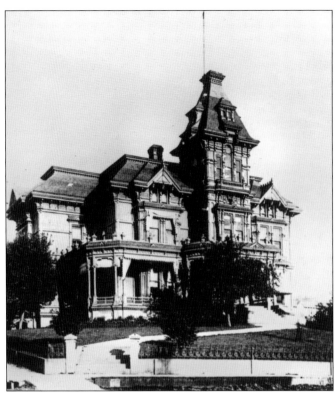

**McNaught Mansion, c. 1889.** The mansion was located on Fourth Avenue and was the residence of attorney James McNaught. It was built in 1883 and became the first home of the Rainier Club. McNaught leased the building to the club for $100 a month, and the club met there from 1888 to 1892. (Courtesy UWLSC.)

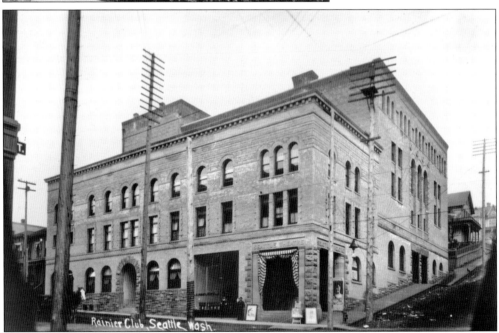

**A Second Home for the Rainier Club.** The second home of the Rainier Club was located at Third Avenue and Cherry Street and had previously been the Seattle Theater Company building. The club was there from 1892 to 1904. By 1914, the building had been torn down and rebuilt as the Arctic Club. (Courtesy UWLSC.)

RAINIER CLUB FINDS A PERMANENT HOME. In 1904, the club made the decision to lease land at Fourth Avenue and Marion Street and enlisted the services of two Spokane architects, Kirtland K. Cutter and Karl G. Malmgren. They designed a stately building in the style of the Jacobean manor houses of England. Construction started in January 1904; nearing completion in March, there was a fire that delayed the opening until September 30, 1904. (Courtesy UWLSC.)

PURCHASE OF THE LOT NEXT DOOR. In 1923, the club purchased the lot next door at Fourth Avenue and Columbia Street for an addition that would extend the facade to a new wing and add a tower. The dining and gaming rooms, along with the lobby, were moved to the south end. That opened up the Ladies Annex on the opposite side, also adding apartments and more space for meeting rooms. The firm of Bebb and Gould was selected for the design, which remains today. (Courtesy UWLSC.)

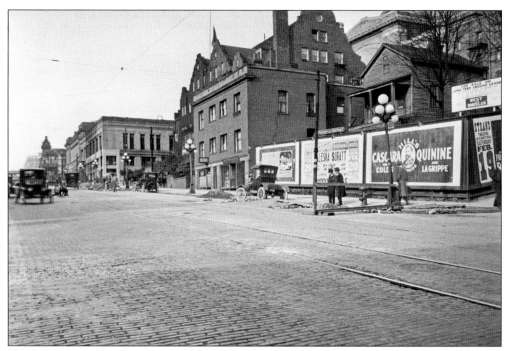

**THE VIEW FROM FOURTH AVENUE AND COLUMBIA STREET.** This view of the corner of Fourth Avenue and Columbia Street shows the cobblestone street in 1921. The Rainier Club appears on the right side just past the brick building. (Courtesy Seattle Municipal Archives.)

**SMILES ALL AROUND.** These unidentified gentlemen are photographed in front of the club's exquisite tapestry around 1920. City club dress was always expected to be professional or formal depending on the occasion. (Courtesy UWLSC.)

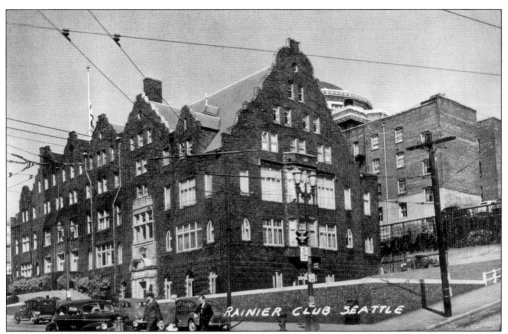

**RAINIER CLUB SEATTLE.** A view of a more modern-day Rainier Club, around 1940, shows the building from the south looking north. The building was granted landmark status in December 1986 by the City of Seattle. (Courtesy UWLSC.)

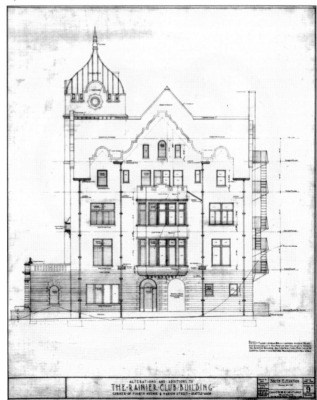

**THE PLANS FROM 1919.** This architectural drawing from the firm of Bebb and Gould shows the plans for the elevated buffet for the South Wall in the library on the corner of Fourth Avenue and Marion Street. (Courtesy UWLSC.)

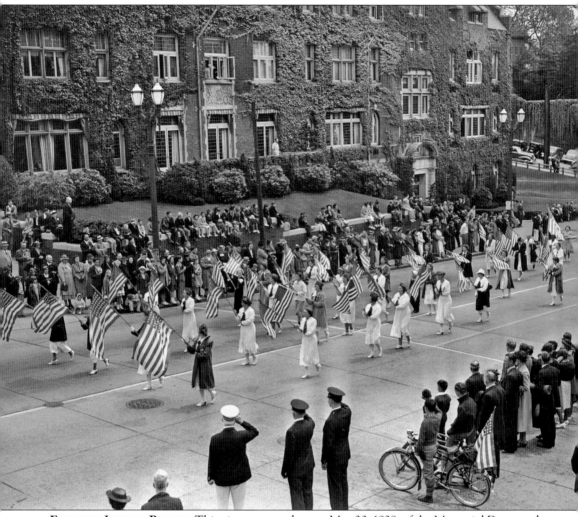

**EVERYONE LOVES A PARADE.** This picture was taken on May 30, 1938, of the Memorial Day parade as it passed the Rainier Club. The marchers walking by are women carrying American flags, and onlookers in military dress salute the flag. (Courtesy MOHAI.)

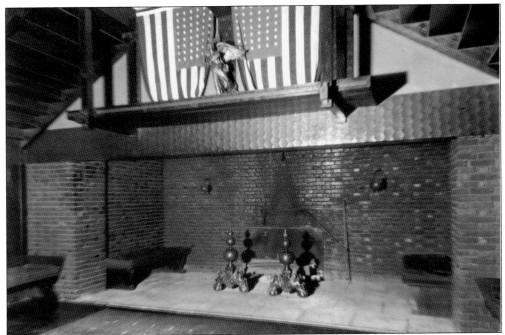

**A Cozy Place to Reflect.** The hearth in the Rainier Room is large and beckoning on a rainy night. The Rainier Room was originally the Banquet Room. In 1960, improvements were coordinated by architect William Bain and completed for a cost of $133,000. It was felt that the updating would help to keep the club contemporary and thus keep the membership rolls full. (Courtesy MOHAI.)

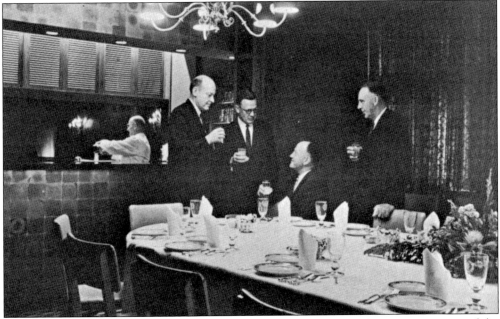

**Cocktails and Conversation.** These unidentified men enjoy a relaxing time in one of the many dining rooms the club has to offer. Simplicity and elegance are hallmarks of the Rainier Club. (Courtesy MOHAI.)

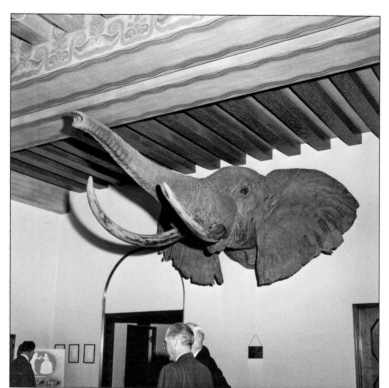

**JOHN EDDY'S TROPHY ELEPHANT HEAD.** Located in the club lobby, this huge elephant head trophy graced the same room as a portrait of Adm. Peter Rainier. The head has been donated to MOHAI and no longer hangs there, but the room is resplendent and stately with a warm, comfortable air. This picture comes from the 1950s and shows off the beautiful carved ceilings. (Courtesy MOHAI.)

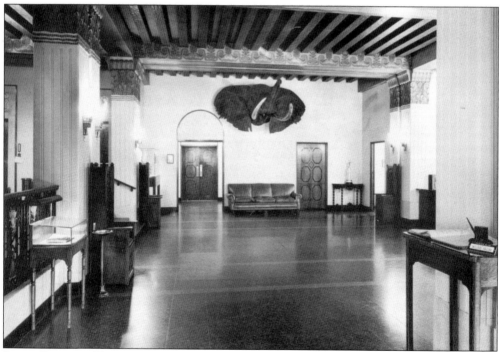

**SIMPLY ELEGANT.** This is another 1950s view of the Rainier Club lobby with a view of John Eddy's trophy elephant head. The lobby has comfortable seating, high-beamed ceilings, and handsomely carved pillars. (Courtesy MOHAI.)

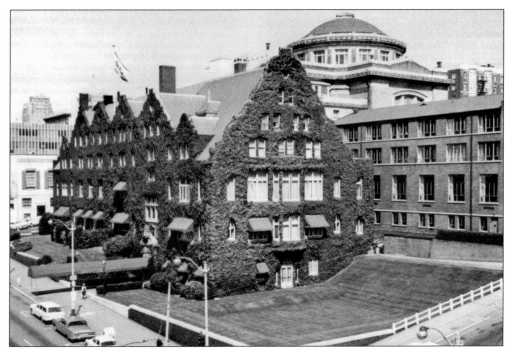

**THE CLUB MOVES FORWARD.** This view is of the club in the 1960s, with its covered entrance and awnings sheltering the windows from the sun. With membership concerns in 1962, the Rainier Club entertained the idea of allowing the College Club of Seattle to merge their 300 members into the club. This was met with strong opposition by the members of the Rainier Club concerned about overtaxing of club facilities. (Courtesy MOHAI.)

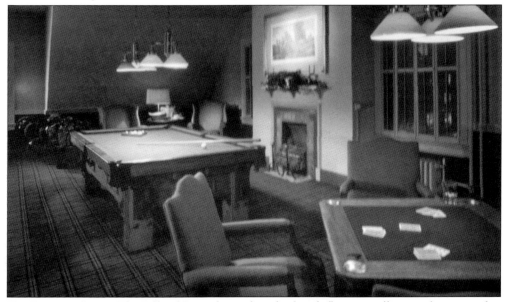

**THE BILLIARD ROOM.** The Billiard Room located on the fourth floor—in all its simplicity—evokes a warm atmosphere where you can leave the pressures of the world outside. The soft colors and simple design of the furniture lend themselves to the game room in a private residence. This photograph is from around 1988. (Courtesy Clinton White.)

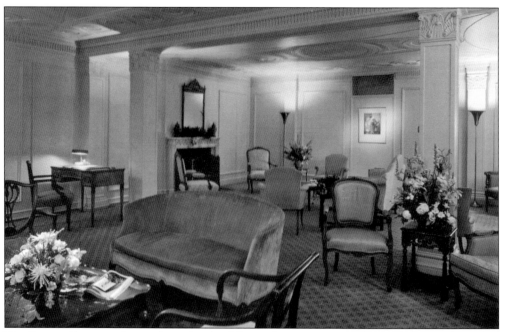

THE LADIES LOUNGE. Located on the third floor, this room is a quiet respite from a busy day. Dimly lit and charmingly furnished, it offers ladies a place to visit or just relax. This photograph is from around 1988. The Rainier Club was a men-only club until 1978; until then, ladies had to use a side entrance. (Courtesy Clinton White.)

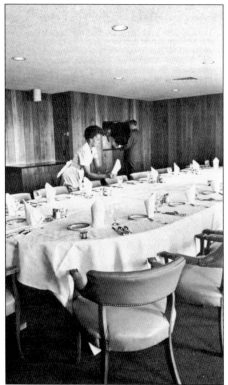

PRIVATE DINING ROOM. This graceful and well-designed area, with its high ceilings, is a perfect place to gather for cocktails or afternoon tea. Tastefully appointed, it has been the scene of many happy events over the club's 104 years in its present location. (Courtesy Clinton White.)

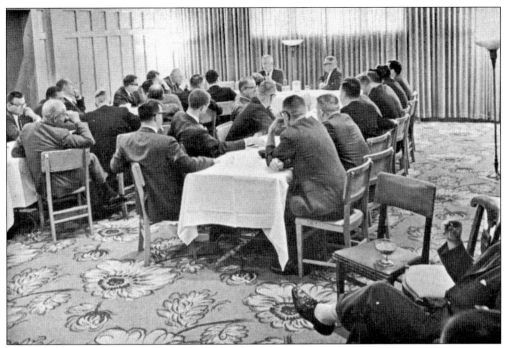

**MEETING ROOM.** The club, while a wonderful venue for parties and family events, has also met the needs of many captains of industry, political leaders, and movie stars of the day. (Courtesy Clinton White.)

**DINING ROOM, c. 1960.** The main dining room has always been a chic area of the club. The decor, while changing with the fashion of different eras, has always reflected the graceful tone set by the club members. The club would also cater events at one's home, even providing glasses and ice! (Courtesy Clinton White.)

**A BUFFET FIT FOR THE MOST DISCERNING MEMBER.** Always highly prized in any club, the chef carries the success of the club in his hip pocket. The club chef and his staff are relied upon to provide only the most delicious and pleasing delicacies for club members and guests. The staff in a private club knows well the needs of members, and seeing them on an almost daily basis builds strong relationships. (Courtesy Clinton White.)

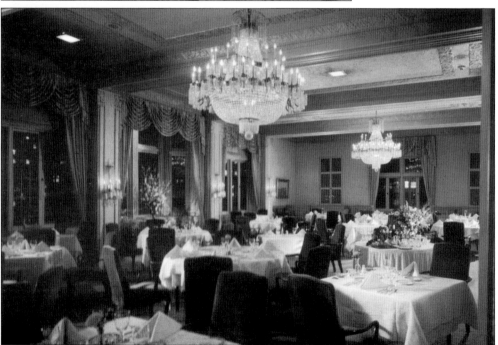

**THE MAIN DINING ROOM.** This picture of the main dining room from around 1970 shows its beautifully set tables and well-appointed room. Meals in private clubs still remained exceptionally popular in this time period. There were always friends to meet with, and the club became a way of life. (Courtesy Clinton White.)

**ARTIST'S RENDERING OF THE RAINIER CLUB.** An architectural sketch of the Rainier Club by William Bain shows the possibility for an annex over the parking concourse. This did not take place, nor did the merger of the College Club with the Rainier Club, proposed in 1963. The members favored gradual change and additions to their club. (Courtesy Clinton White.)

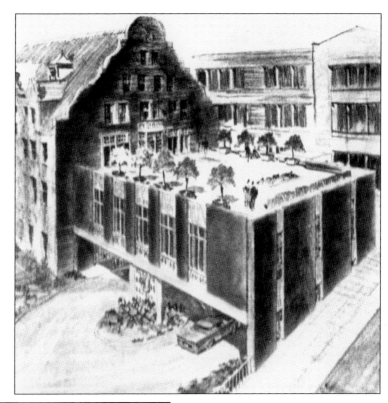

**DINNER AT THE CLUB.** Well-dressed and chicly coiffed, this unidentified lady and her husband look forward to a wonderful evening at the club. The club became the extension of one's home, and dinners and programs were a regular occurrence. (Courtesy Clinton White.)

**LIBRARY.** One of the most important functions of a private club is the socialization they provide. Strong friendships between members last for generations. By attending programs and parties together and having strong ties to the club and its future, people create an environment of mutual respect. (Courtesy Clinton White.)

**WINDS OF CHANGE.** In 1978, because of the changes in society and the realization that exclusion was not acceptable, the club changed its bylaws and went from an all-white, all-male venue to a place where all could participate. The first black man asked to join was Andy Smith, president of Pacific Bell. The first woman to become a member was Judge Betty Fletcher. She was also the first woman to head the Seattle–King County Bar Association. (Courtesy Clinton White.)

## Four

# THE SEATTLE TENNIS CLUB

The first inception of the Seattle Tennis Club was on Madison Street. Over the years, the club would gradually move up Madison Street to lease more locations for courts, until it found a new home on the far side of First Hill, in Madison Park on McGilvra Boulevard.

The Seattle Tennis Club was officially founded as the Olympic Tennis Club on August 2, 1890. Originally the club had two clay tennis courts on Madison Street and Twelfth (now Minor) Avenue on First Hill behind the Stacy Mansion (the site of the University Club) and the Carkeek Mansion on Madison Street and Boren Avenue.

A meeting was called at the Rainier Club on May 28, 1891, with Clarence B. Tood as the chair and Warren P. Skillings as the secretary, to institute bylaws, and they limited the membership to 75 members. By that time, they had three tennis courts. By 1894, the club had 27 members and 10 associates. Dues were set at $10, with a $10 initiation fee. The club expended $79.80 for a "clubhouse," which was a sort of shed. A year later, lockers and a shower were added at a cost of $72.50. By this time, there were four tennis courts.

In 1896, a new constitution and bylaws were instituted, changing the name to the "Seattle Tennis Club." The ladies' branch was limited by the bylaws to 60 members, but these formidable ladies contributed a third of the funds necessary to build an addition to the clubhouse, a grand sum of $36.

By 1903, the club had moved up the hill again, leasing a site on the northwest corner of Madison Street and Summit Avenue. By this time, the membership was 60 active men and 50 associates, and the ladies' branch was expanded to allow 124 women.

In 1919, it was determined that the Firlock Canoe Club on Lake Washington, which had been owned by the Seattle Athletic Club (forerunner of the Washington Athletic Club), was under foreclosure and up for sale. The property was purchased for $22,500. By 1922, the club would purchase an additional 130 feet of waterfront for $3,300. The ladies' branch borrowed $6,000 to build an addition consisting of a dining room and ballroom. In 1928, the clubhouse was expanded further, adding new showers, a private dining room, and squash courts. By 1981, the club had added an additional 830 feet of waterfront to the original property.

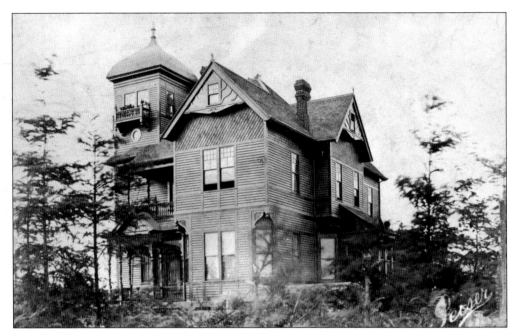

CARKEEK MANSION, C. 1894. The Carkeek Mansion was built in 1884 for Morgan Carkeek and his wife, Emily. Both the Seattle Tennis Club and the Seattle Historical Society trace their beginnings to this mansion; the tennis club had courts behind the building. (Courtesy MOHAI.)

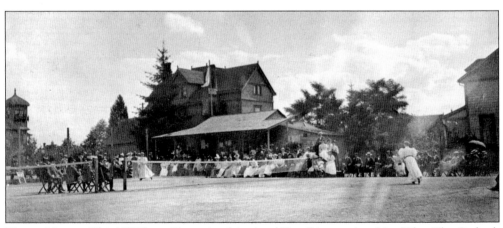

TENNIS MATCH. This 1897 State Championship pitted Kate Riggs against May Riley. The Carkeek Mansion can be seen in the background. (Courtesy Clinton White.)

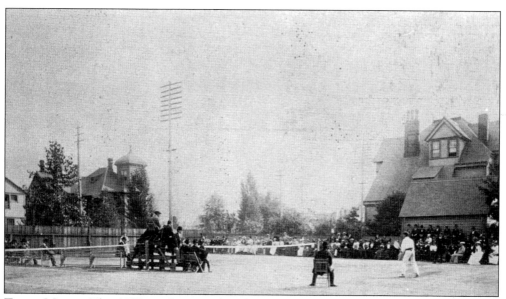

TENNIS MATCH. This 1895 match was at the Olympic (Seattle) Tennis Club with the University Club. The Carkeek and Stacy Mansions can be seen in the background. The Stacy Mansion would become the University Club. (Courtesy Clinton White.)

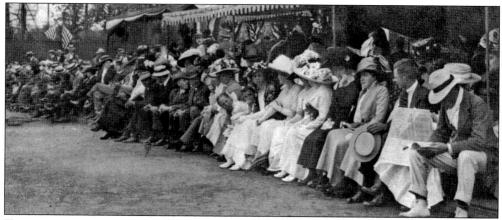

TENNIS MATCH SPECTATORS. These fashionable spectators had no actual clubhouse when this picture was taken, just a sort of shed. Later lockers and a shower were added. (Courtesy Clinton White.)

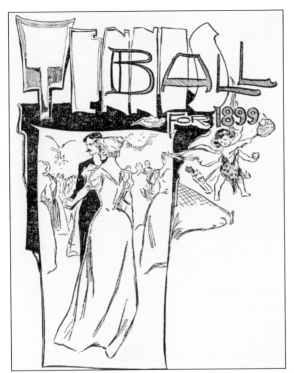

**TENNIS BALL, 1899.** The Tennis Ball was one of the most fashionable events in Seattle society for decades. The stag line at early events was enormous; men outnumbered women three to one. (Courtesy Clinton White.)

**TENNIS CLUB TOURNAMENT.** This 1899 program is from the 10th annual state tennis tournament. The sport of lawn tennis was born in 1873 and became wildly in vogue with the upper classes in the 1880s and 1890s. The rules have not changed significantly since the 1890s. (Courtesy Clinton White.)

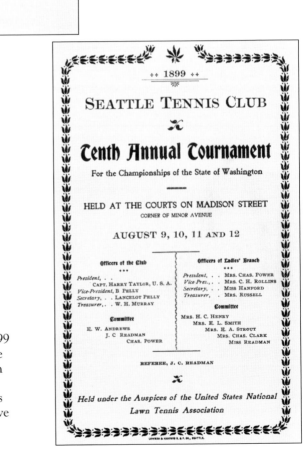

**WOMEN TENNIS PLAYERS.** The 1890s brought a reform in women's dress, especially for sports. Although these 1900s outfits look unwieldy by today's standards, they were a great improvement over the bustle! The outfits of these two young Seattle ladies (Ethel Preston right, unidentified below) took their style from menswear, which was considered quite risqué in the day but involved up to four petticoats. Wednesdays were set aside as "ladies days" at the Tennis Club. Dues for ladies were $2 a year, and ladies were entitled to use the courts until 1:00 p.m. daily and all day Wednesdays. In many ways, the women of the Tennis Club were the driving force behind its success. (Both Courtesy author's collection.)

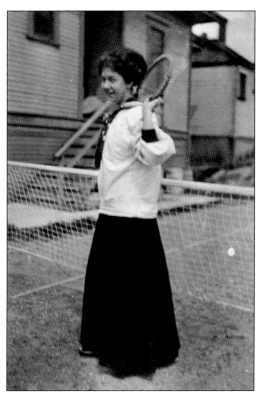

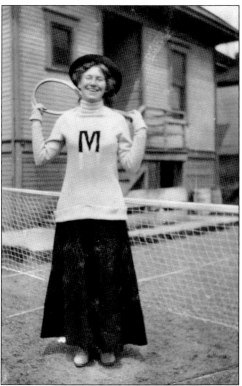

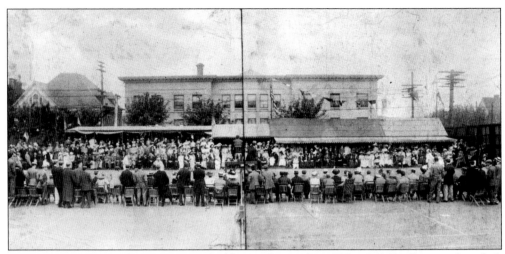

**TENNIS CLUB, 1911.** This 1911 men's double match pitted Joe Tyler, J. F. Foulkes, unidentified, and Prescott Smith. The original shed clubhouse can be seen in the background. (Courtesy MOHAI.)

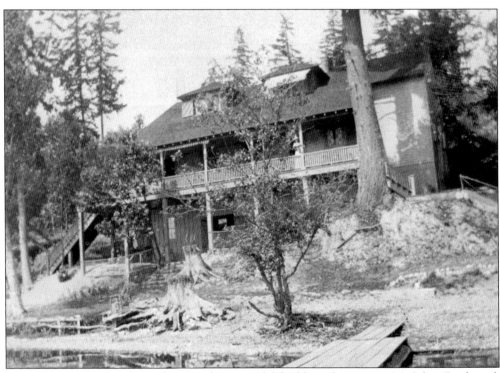

**FIRLOCK CANOE CLUB.** This is the second Tennis Club building, this time on McGilvra Boulevard. Tennis Club members had already spent a good deal of time enjoying the bandstand at Madison Park; they would take the cable car down from the courts at Madison Street. The Canoe Club was acquired from the Seattle Athletic Club. (Courtesy Clinton White.)

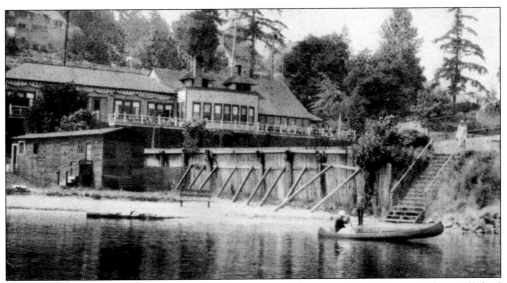

**SEATTLE TENNIS CLUB, 1929.** You can see the various additions to the clubhouse. The small shed in the foreground is the women swimmers' dressing room. (Courtesy Clinton White.)

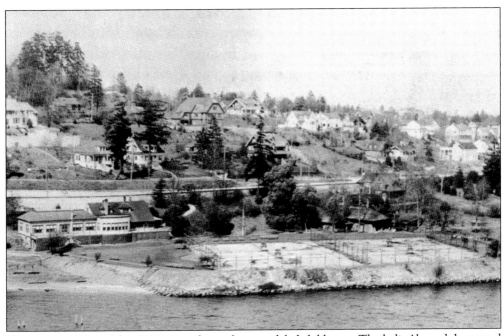

**WATERFRONT VIEW.** This 1920s view shows the remodeled clubhouse. The ladies' branch borrowed $6,000 to add a new dining room and a ballroom. The men's branch put up the collateral for the loan. (Courtesy MOHAI.)

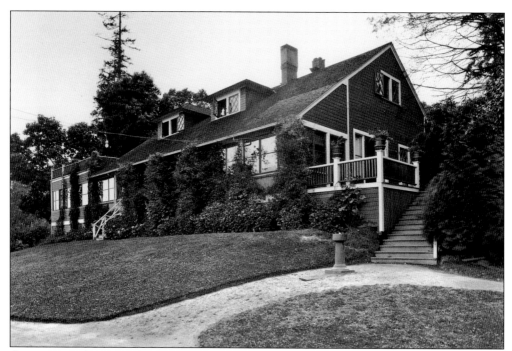

CLUBHOUSE. These two photographs show the clubhouse lawn; the original Canoe Club building sat right on the water. After the Ballard Locks were built in 1917, the level of Lake Washington was lowered 14 feet. (Both courtesy MOHAI.)

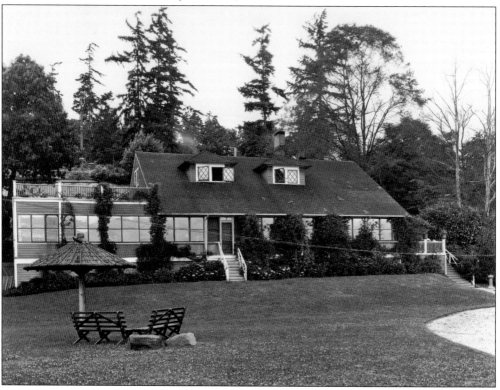

CLUBHOUSE. The various remodels and additions of the Tennis Club can clearly be seen in this 1948 photograph. By 1947, the club would have 1,582 members, becoming one of the largest and oldest tennis clubs in the country. (Courtesy MOHAI.)

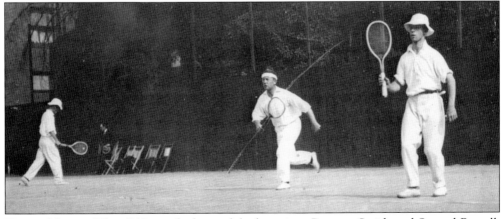

TENNIS MATCH. This 1912 match shows club champions Prescott Smith and Samuel Russell. Russell was the state champion in 1904, 1910, 1913, and 1916 and was the club president from 1913 to 1922. Unlike women's tennis togs, men's tennis clothes have not changed significantly since the turn of the 20th century. (Courtesy MOHAI.)

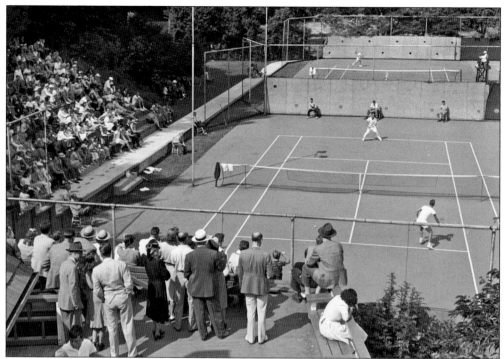

**TENNIS MATCH.** These pictures show a tennis tournament in 1949 at the Tennis Club. The clubhouse can clearly be seen in the background. (Both courtesy MOHAI.)

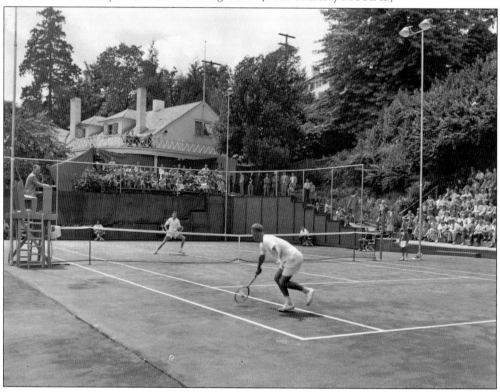

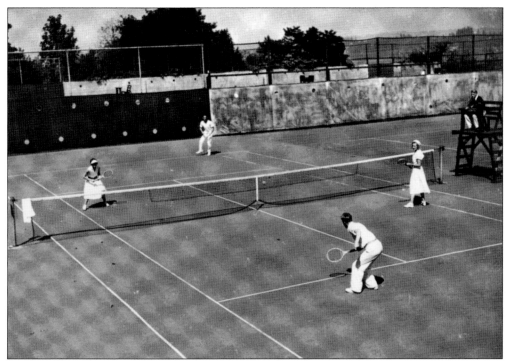

**TENNIS CLUB MATCH.** The names of the players in this mixed doubles match are unknown, but the club is still host to tournaments today, including Tennis Week in July. (Courtesy MOHAI.)

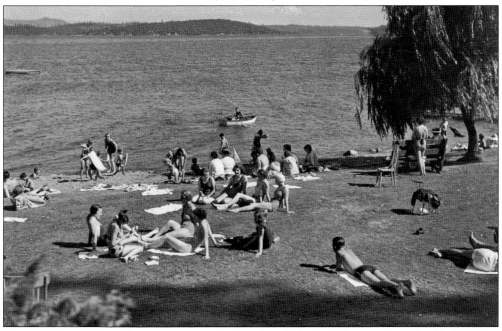

**BEACH.** These club members are enjoying the beach on Lake Washington; the club added 830 feet of waterfront to the original property in 1981, as well as a swimming pool, shell house, sailboat dock, and boathouse—a far cry from the original Canoe Club house or the shed on Madison Street. (Courtesy MOHAI.)

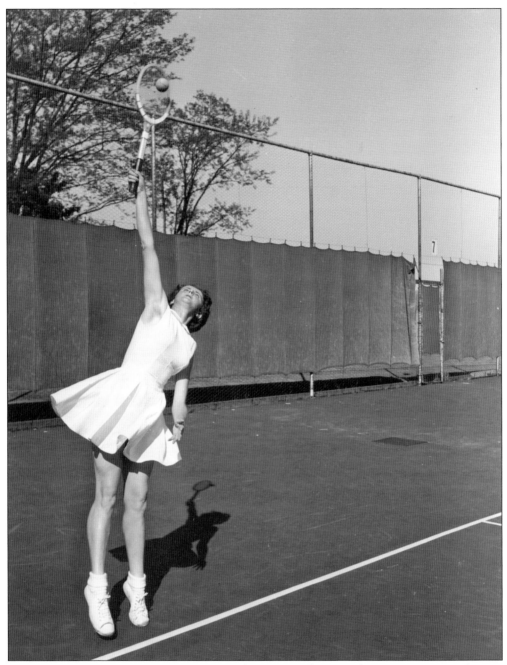

**TENNIS PLAYER JULIE FITZPATRICK, 1955.** Julie Fitzpatrick is seen here competing in the city tennis tournament. She was seeded second in the women's division and was in the semifinals. (Courtesy MOHAI.)

*Five*

# THE SUNSET CLUB

The Sunset Club sits majestically on First Hill as it has since 1915. It is steps away from downtown Seattle shopping and entertainment venues but has the feeling of being located in a quiet neighborhood environment. This beautiful Georgian-style clubhouse designed by Josef Cote is a tribute to elegant living in the truest sense of the word.

The club was originally founded in 1913 as a women's club for the ladies of Seattle. The original charter members were Mrs. William Biglow, Mrs. Harry R. Clise, Mrs. Wallace G. Collins, Mrs. John C. Eden, Mrs. John Edwards, Mrs. Joshua Green, Mrs. J. C. Haines, Mrs. Horace Henry, Mrs. James Lowman, Mrs. William H. McEwan, Mrs. Alexander B. Stewart, Mrs. C. D. Stimson, Mrs. F. S. Stimson, Mrs. Charles P. Spooner, and Mrs. Henry Whitney Treat. These names are synonymous with Seattle society; many of their husbands were charter members of the University Club. During World War I, the club mobilized, turning the library and three of the guest rooms into work rooms and sewing gauze bandages and surgical shirts. These society ladies also knit scarves, gloves, and mittens for the men in the trenches.

The club is exquisitely appointed with beautiful furnishings, and through the years, has been professionally decorated by interior designers such as James Marzo of San Francisco. There is a library, large drawing room, and guest rooms for out-of-town members. Originally there was a garden to the south with apple trees where tea was often served.

Bertha Knight Landes was a charter member of the Sunset Club, a past president of the Woman's Century Club and General Federation of Women's Clubs–Seattle, and an active member of the Women's University Club. She became mayor of Seattle in 1926, a position that has not been held by a woman before or since.

From the very beginning, history and tradition have been an important part of this club's culture. For generations, families have continued to enjoy this landmark Seattle club with its genteel manner and its magnificent clubhouse. The club very often will have lecturers speak on interesting topics.

From its founders to the present-day membership, one thing has remained: loyalty to the club and to each other. While Seattle has grown and changed, this club has retained the foundation laid for it so many years ago. In 2013, the Sunset Club will celebrate its 100th anniversary.

**Club Building.** The Sunset Club was built in 1915 and is located on First Hill. The clubhouse is of the Georgian style with a brick facade. The building houses public rooms, which include a library, drawing room, ballroom, and several dining rooms. (Courtesy UWLSC.)

**Mrs. Thomas Douglas Stimson.** Mrs. Stimson was the president of the Sunset Club from 1927 to 1929. The Stimson family, of timber fame, has always been very involved in the Sunset Club. (Courtesy Clinton White.)

**SUNSET CLUB ALL-STAR CAST.** This is one of many musicales put on by the Sunset Club. The original 1928 program is printed in color on blue paper; the peacock in the corner is the emblem of the Sunset Club. Much controversy has arisen over the years as to the origin of the logo, but the peacock symbolizes elegance. (Courtesy Clinton White.)

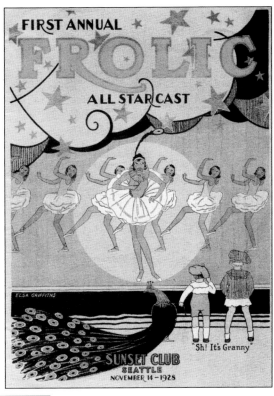

## First Annual Frolic

SUNSET CLUB OF SEATTLE

November 14, 1928

AN OLD FASHIONED MINSTREL SHOW
WITH MODERN AMPLIFICATION

*To be concluded with*

"GRANNY'S BALLET"

*Produced and arranged by*
MRS. FRANCIS G. FRINK

MINSTREL SHOW
*Under the direction of*
MR. FRANK COOMBS

PROGRAM

*Interlocutor*

MAUD EATON

END MEN

| | | |
|---|---|---|
| Eliza Leary | Alma Ballinger | Freda Tilden |
| Achsah Moore | Emma Stimson | Betty Lilly |
| Madeline Coman | Mary Louise Hoge Sullivan | |

CIRCLE

| | | |
|---|---|---|
| Sylvia Smith | Blanche Van Tuyl | Mary de Veuve |
| Ethel Hoge | Julia Youell | Genevieve Blethen |
| Marguerite Field | Armene Lamson | Maude Fox |
| Katherine Corbet | Nellie Cornish | Olive Gaffney |
| Sidonia Wetherill | Lenore Ostrander | Relura Todd |
| Minna Parks | Ruth Alexander | Ann Sharples |
| Willye White | Mdge Frink | Hazel Young |
| Kate Morgan | Jessie Hedges | Josephine Fransioli |
| Edna Farnsworth | Ethel Stacy | Susie Campbell |
| Helen Barnes | Augusta Frazier | Lurena Ferry |
| | Jessie Garrett | |

**FIRST ANNUAL FROLIC.** One of the committee chairs of the Frolic was Nellie Cornish, founder of the Cornish College of the Arts in Seattle in 1914. She served as director of the Cornish school for its first 25 years. (Courtesy Clinton White.)

81

**MRS. RAYMOND FRAZIER.** Mrs. Frazier was just one of the many club members appearing in the Frolic. Her husband, Raymond Frazier, was the president of Washington Mutual Bank, a member of the University Club, and one of the founders of the College Club. (Courtesy Clinton White.)

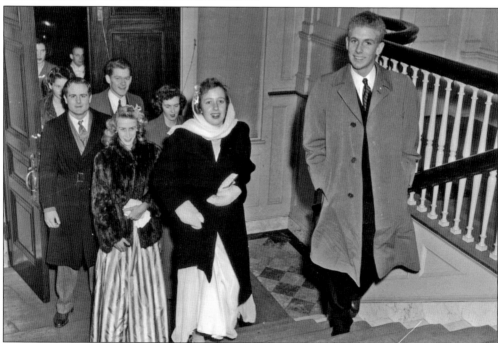

**CELEBRATING THE SEASON.** Guests arrive for a Christmas party, or possibly a debutante dance, at the club in 1944. Everyone is dressed in evening wear and smiles anticipating the festivities, which were a welcome change in the war years. (Courtesy MOHAI.)

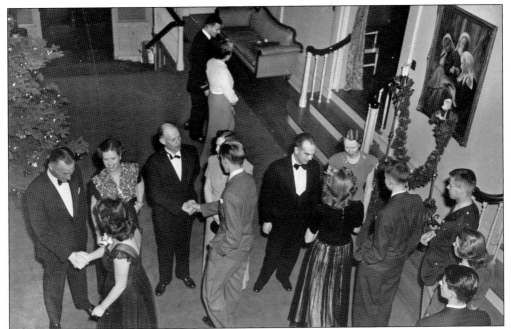

**'TIS THE SEASON.** Guests are greeted with a handshake and a smile going through the receiving line to share conversation with the sponsors of the event in 1944. During the influenza epidemic of 1917, the club raised money to pay for food, Christmas gifts, and a Christmas tree for ill and wounded soldiers at Fort Lewis. (Courtesy MOHAI.)

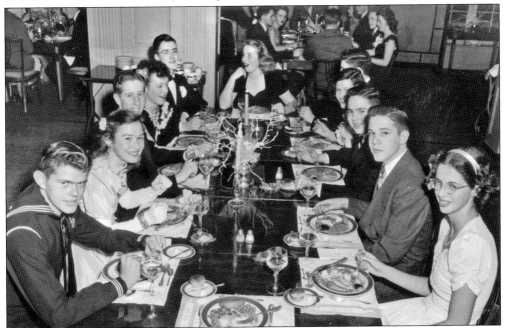

**THE NEXT GENERATION.** These young people are enjoying a lovely dinner and laughter while posing for a picture. The ladies are chicly dressed in the fashion of the day for this 1944 picture. The Sunset Club is elegantly furnished and gives the feeling of an elegant private residence. (Courtesy MOHAI.)

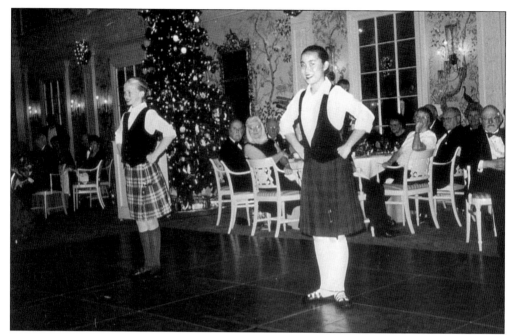

**CHRISTMAS.** Performing a jig for an interested audience at the English Speaking Union (ESU) annual Christmas Ball, dancers entertain on this festive occasion. For years, the annual ball was sponsored by member Betty Wasson, although she and Gretabelle Stimson, a supporter of the Arthur G. Dunn II Guild of the Maryhill Museum of Art, have recently passed away. (Courtesy Elizabeth Buzzell McKenzie.)

**CHRISTMAS 2000.** Holiday carols resound at this Christmas 2000 ESU Christmas Ball. From left to right are unidentified, Bob Dunlap, unidentified, Robert Milner, Don McKenzie, Fred Kleinschmidt, James Smith, Vincent Jolivet, and James Raisbeck. (Courtesy Elizabeth Buzzell McKenzie.)

CHRISTMAS 1997. Don and Elizabeth McKenzie pose in front of the Christmas tree, which shows off the lovely murals that decorate the club. The Sunset Club is the scene of many wedding receptions and parties. (Courtesy Elizabeth Buzzell McKenzie.)

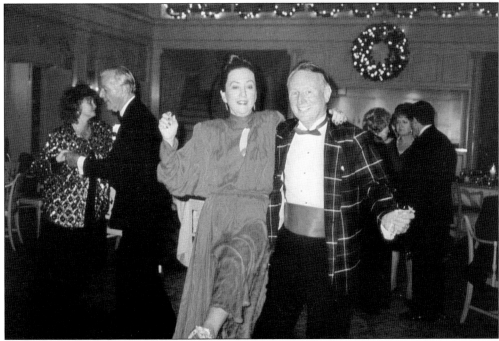

CHRISTMAS 2002. Taking a turn on the dance floor at the 2002 ESU Christmas Ball are, from left to right, Susan Wilson, Vincent Kelley, and Don and Elizabeth McKenzie. Each room is decorated in the classic style with light, airy rooms. (Courtesy Elizabeth Buzzell McKenzie.)

**CHRISTMAS BALL 2007.** From left to right are Bill Maschmeier, Don McKenzie, Norman Matheson, and John Matheson dressed in their finest kilts. (Courtesy Elizabeth Buzzell McKenzie.)

**ONE MORE TURN AROUND THE DANCE FLOOR.** Patricia Haggerty and Bill Maschmeier enjoy a lovely time at this beautiful club at the ESU Christmas Ball in 1997. This picture was taken out in the checkerboard hallway; all the furniture was moved out to extend the dance floor into the hall on this occasion. (Courtesy Elizabeth Buzzell McKenzie.)

*Six*

# THE UNIVERSITY CLUB

The University Club is the smallest, most private, exclusive, and elusive club in Seattle. The club seeks neither new members nor publicity but remains one of the bastions of private club culture in Seattle. The club was modeled on the University Club of New York; as Eastern investors and captains of industry moved to Seattle, the idea of the University Club was born in 1900. Founding members included Judge Thomas Burke, "The Man Who Built Seattle;" Clarence Blethen, editor of the *Seattle Times*; Henry Suzzallo, president of the University of Washington; Henry Whitney Treat, Ballard real estate developer; and railroad magnate Sam Hill.

The University Club also has the distinction of being one of the only private clubs in Seattle still housed in the original club building on Madison Street. (The Washington Athletic Club, built in 1930, is the other club still in its original building.) The main part of the building was the old M. V. B. Stacy mansion, purchased in 1901 by Lyman Colt, a member. An annex on Madison Street containing the card room and billiard room was added in 1906. Until World War I, up to 10 permanent residents lived at the club, and breakfast was served daily. In 1919, the club purchased the property. Originally, there was a small building to the rear used as a squash court, but it was demolished when the new dining room was built in 1953 at the northeast corner of the building. The old dining room became the ladies' annex, the only part of the building open to ladies.

The University Club has survived two world wars. In World War I, 70 University Club members served as officers; Capt. Howard Hughes of the 91st Division was killed in the Argonne Forest. Sixty-one University Club members served as officers in World War II; Major Burnett and Capt. Carl Huessey were killed in the South Pacific. Club employees Sam and Kay Kimura were interned during World War II. Sam would later become the club manager after the war.

The University Club has a proud tradition of Christmas shows, summer outings, and a New Year's Day Tea, as well as being one of the original four Seattle clubs active in the Inter-Club Bridge League. Three presidents of Boeing have been members: William Boeing, Philip Johnson, and William Allen. The club has been home to the presidents of the University of Washington, mayors of Seattle, and captains of industry, and its policy of privacy and exclusivity continues today.

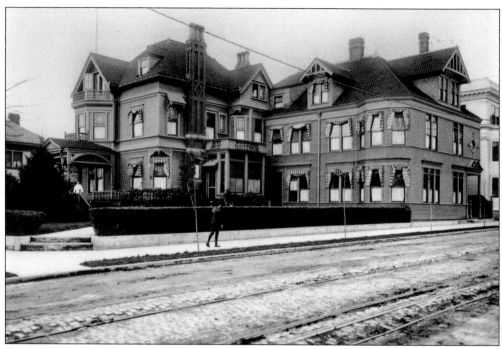

**THE UNIVERSITY CLUB.** The club building remains in almost pristine condition; one of the greatest unforeseen consequences of the club's history has been the preservation of one of Seattle's original historic mansions against encroaching development on First Hill. (Courtesy UWLSC.)

**FIRST PRESIDENT.** E. W. Andrews was the first president of the University Club, from 1901 to 1908, a graduate of Yale University, and a well-respected banker. (Courtesy MOHAI.)

**HENRY WHITNEY TREAT.** Member Henry Whitney Treat came to Seattle in 1902 and bought up hundreds of acres of land north of Ballard. He named Loyal Heights after his daughter Loyal and built a cable car line to his new development. His wife, Olive Graef Treat, was a charter member of the Sunset Club, one of the original 15 members who met for tea in 1913. The picture below shows Treat with his teams of horses, of which he was justly proud. (Both courtesy MOHAI.)

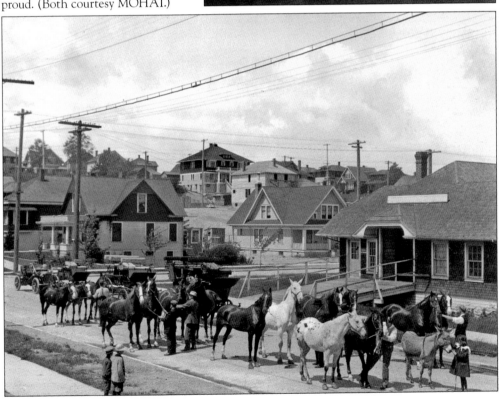

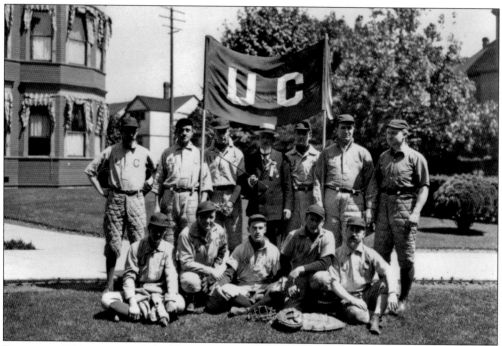

**BASEBALL.** This picture of the University Club baseball team was taken in 1906 by noted Seattle photographer Asahel Curtis. You can just see the corner of the club building on the left. (Courtesy UWLSC.)

**JUDGE BURKE.** Club member Judge Thomas Burke was known as "The Man Who Built Seattle." Burke was a famous jurist, civic booster, and promoter of racial tolerance; the Burke Museum is named after him. His wife, Caroline McGilvra Burke, was one of the founding members of the Sunset Club. (Courtesy Seattle Municipal Archives.)

**AN EVENING AT THE UNIVERSITY CLUB.** The gentlemen enjoying an evening at the club are unidentified, although the gentleman below at far left holding a banjo is Dietrich Schmitz, a president of Washington Mutual Bank. Two other presidents of the bank would play a part in the University Club: Raymond Frazier and his son Stuart. Raymond would play a significant part in the founding of the College Club; Stuart Frazier would be University Club president from 1952 to 1953. (Both courtesy UWLSC.)

**AN EVENING AT THE CLUB.** These pictures complete a set taken at the University Club in the 1950s. Many men of this era, including perhaps these unidentified gentlemen, belonged to several clubs; Capt. Kenneth McAlpin of Broadmoor belonged to the University Club, Seattle Tennis Club, and the Seattle Yacht Club because each provided a different set of amenities. (Both courtesy UWLSC.)

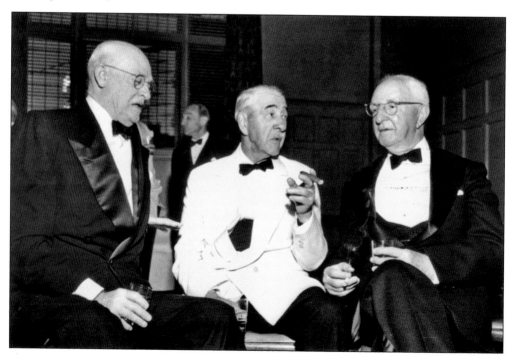

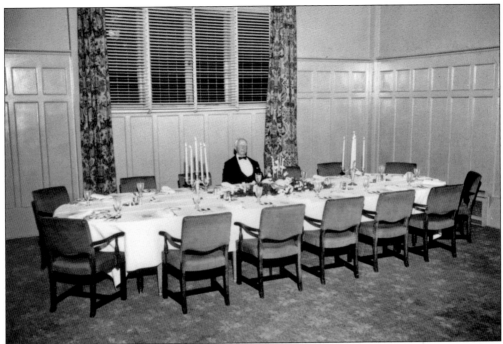

**DINING ALONE.** It is unknown if the gentleman is waiting for his fellow diners or if he is just enjoying a solitary meal, but this picture gives a good view of the dining room of the University Club. (Courtesy UWLSC.)

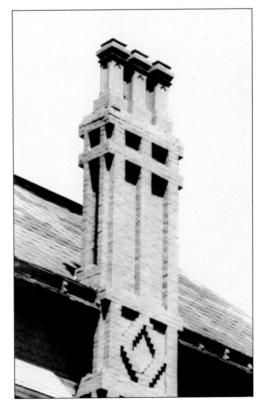

**THE CHIMNEY.** The ornate triple-stacked chimney of the University Club is one of its more interesting architectural features. (Courtesy MOHAI.)

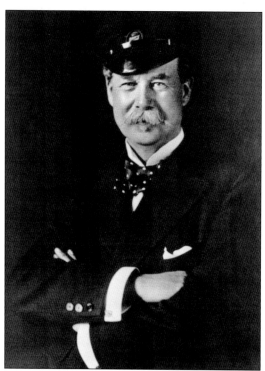

**SIR THOMAS LIPTON.** Sir Thomas Lipton of tea company fame sailed his famous yacht, *Shamrock*, to the West Coast in 1915. He was a guest participant in the bridge tournaments held that year at the Tennis Club. Upon his return, he sent the handsome sterling silver cup as a token of his pleasure and esteem. (Courtesy College Club.)

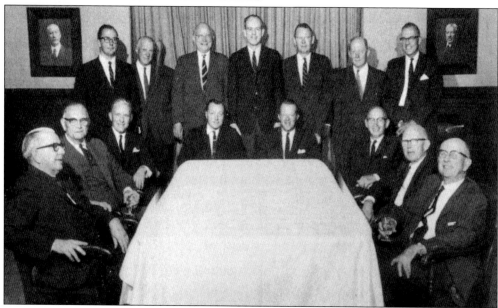

**THE SIR THOMAS LIPTON CHAMPIONSHIP.** The Sir Thomas Lipton Bridge Championship has been played since 1915. The first clubs in competition were the Arctic, College, Rainier, Tennis, Washington Athletic, and University Clubs. Although it unclear which one person is unidentified, this 1966 championship team is labeled as, from left to right, (seated) E. S. Dillon, E. R. Bowden, M. Milburn, W. A. Coburn, M. Pringle, P. W. Bailey, J. S. Shaw, and H. M. Bolcom; (standing) C. A. Pelly, R. H. Loe, P. Miller, C. M. Ballard Jr. (captain), G. V. Powel, and W. D. Bowden. (Courtesy UWLSC.)

*Seven*

# The Washington Athletic Club

The Washington Athletic Club (WAC) opened its doors on December 16, 1930, not the most auspicious of times to promote a new downtown club. In early 1928, Noel B. Clark tried to promote a new 12-story athletic club to replace the old Seattle Athletic Club. This initial project, projected at a cost of $100,000, failed from lack of financial backing. New visionaries Edward B. Waite and Jules Charbonneau decided to seek the backing of W. E. Comer, the financier for the Music Box Theater and the Olive Tower apartments. Comer agreed, provided that the club could obtain at least 2,000 businessmen to subscribe. In 90 days, they had signed up 2,600 members. In September 1928, architect Sherwood Ford presented his initial drawings of the art deco building. The projected cost had increased to $200,000, and the building plans had increased to 21 stories, which included 113 bedrooms.

The WAC was the last major tall building to be built in Seattle during the Depression. Not long after it opened, it was threatened with financial ruin and closure, but civic leaders stepped up to the plate to maintain membership and increase income. The WAC weathered the Depression by offering programs for all members of the family, a tradition that continues today. Undoubtedly the most famous WAC member was Helene Madison, who broke 16 world records between 1930 and 1931 and won three gold medals in swimming at the 1932 Olympic Games.

During World War II, a Victory Center took up the entire seventh-floor level, and women members sewed, knit, spun, and weaved and made surgical dressings, paying back the community that helped the WAC weather the Depression. In 1945, the ownership of the clubhouse building was transferred to the membership at a price of $1.35 million. By 1950, the WAC employed 300 people and served between 1,200 and 1,500 meals a day. In 1954, a new four-story addition was designed by the firm of Bain and Overturf, built under the supervision of general contractor Howard S. Wright and Company, which included a 400-seat auditorium, new dining room, and underground parking. In 1970, an additional eight stories were added to the 1954 wing and the entire interior was further modernized. A time traveler from 1930 would have difficulty recognizing much of the modernized WAC, with the exceptions of the newly restored swimming pool and portions of the main lobby.

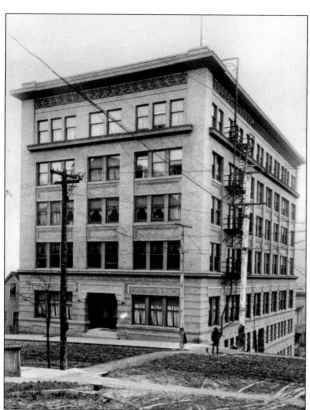

**SEATTLE ATHLETIC CLUB.** This building at Fourth and Cherry Streets in 1909 was the precursor of the Washington Athletic Club. At the time, a gentleman might have to go to the Athletic Club to work out, the YMCA on Fourth Avenue and Madison Street to swim or play handball, First Avenue for a Turkish bath, and elsewhere for a shave, a haircut, and a good meal. Thus did Noel B. Clarke come up with the concept of the all-inclusive Washington Athletic Club. (Courtesy UWLSC.)

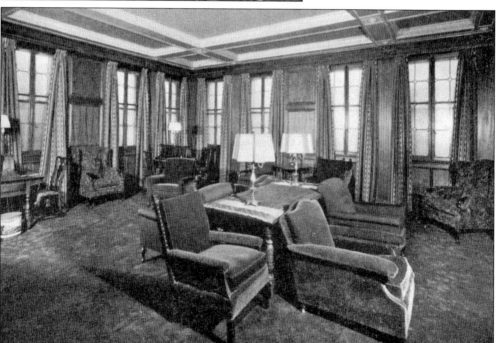

**MEN'S READING ROOM.** This 1930 picture shows the interior of the Men's Reading Room, where members could enjoy a book or periodical in quiet. (Courtesy MOHAI.)

**BARBERSHOP.** The 1930s members would hardly recognize the original barbershop and beauty salon, which has transformed into a spa offering manicures, pedicures, reflexology, table Thai massage, hot rock therapy, and teeth whitening services! (Courtesy MOHAI.)

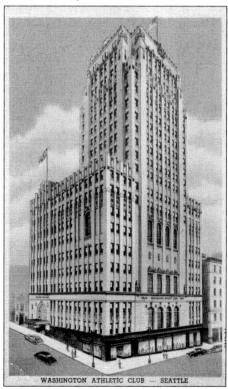

WASHINGTON ATHLETIC CLUB — SEATTLE

**WAC BUILDING.** The original 1930 building included five storefront display openings with fluted terra-cotta surrounds and gray-black granite bulkheads, with ornate cresting, bronze sashes, and terrazzo-paved vestibules. One at the northeast corner remains virtually intact, although the cresting no longer exists. A bronze plaque commemorating Hannah Newman, the original land owner, is still seen at the north end of the building base. (Courtesy Celeste Smith.)

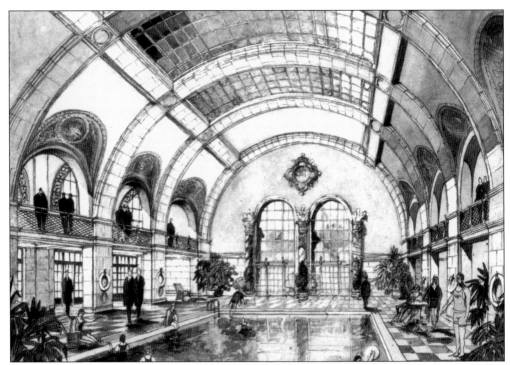

**Helene Madison Pool.** This stylized art deco drawing shows the pool as it was supposed to appear in 1932. The pool was named in Helene Madison's honor in 1968. In 1930, Helene had already broken world records in this same pool. In 1932, a ticker-tape parade for her brought out 175,000 Seattleites, the largest parade in Seattle's history. (Courtesy MOHAI.)

**Helene Madison.** The WAC's most famous member, Helene Madison, broke 16 world records and 116 swimming records in all between 1930 and 1932. She won three gold medals in the 1932 Olympic Games in Los Angeles. The pool shown above is one of two pools named for her; the other is at Ingraham High School. Sixteen-year-old Helene and her coach, Ray Daughters, are seen returning to Seattle after sweeping the indoor nationals in Miami. (Courtesy MOHAI.)

**ENTRANCE LOBBY.** The original 1930s lobby was greatly altered when the formal entrance was relocated in 1954. However, some of the original marble, the elevator doors, and some of the wood paneling remain. (Courtesy Clinton White.)

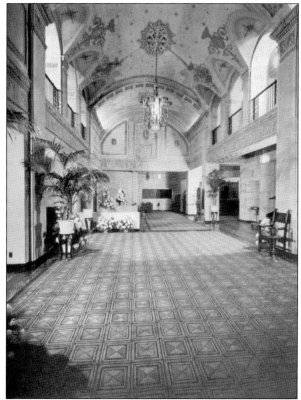

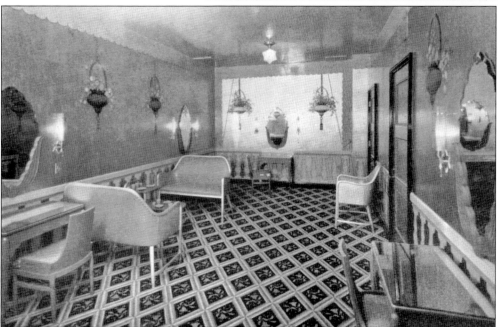

THE "POWDER BOX." No expense was spared in the women's Ladies Room, which featured Italian blue, silver, and red with ivory and black carpet. The furniture and fittings were imported from Austria. (Courtesy Clinton White.)

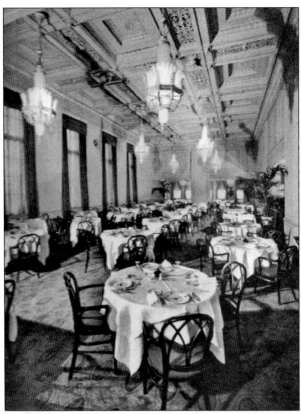

**MAIN DINING ROOM.** The main dining room was decorated in green, ivory, and silver. There was also a women's dining room, where lunch was served daily, and a men's grill adjacent to the card room. The original WAC silverware was made by Reed and Barton. (Courtesy Clinton White.)

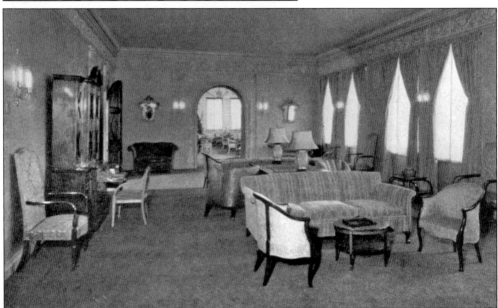

**WOMEN'S LOUNGE.** In 1930, a hostess was available to attend to ladies' needs in the Women's Lounge. Originally a men-only club, the WAC always offered a wide variety of programs for women associates, including a toastmistress group that met at noon for married women and in the evening for single women, as well as a Bicycle Club. (Courtesy Clinton White.)

**MEN'S LOUNGE.** The Men's Lounge on the first floor included many authentic antiques and original paintings. (Courtesy Clinton White.)

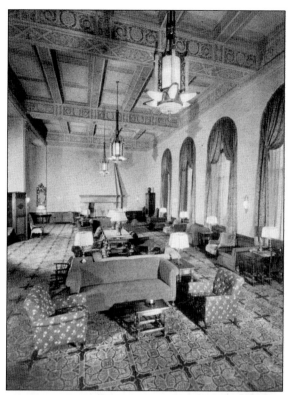

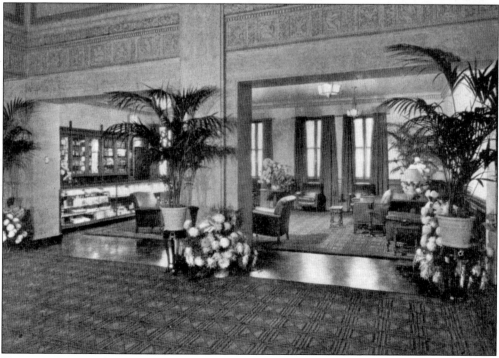

**VISITOR'S ROOM.** The Visitor's Room was adjacent to the Smoke Shop and featured red leather Moroccan-style furniture. (Courtesy Clinton White.)

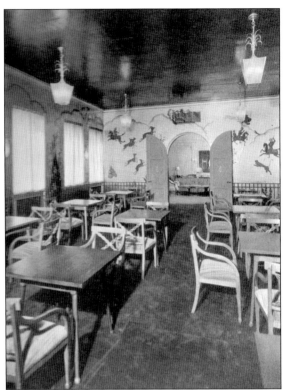

**LADIES' BRIDGE ROOM.** The Ladies' Bridge Room, adjacent to the Ladies' Lounge, was decorated with wine-colored carpets, a gold ceiling, and crystal and silver lamps. The mural was meant to portray ancient Persian sports. Bridge has always been a key component in all of the downtown private clubs, who competed annually for the Lipton Cup; by 1963, the WAC had won 10 championships. (CourtesyMOHAI.)

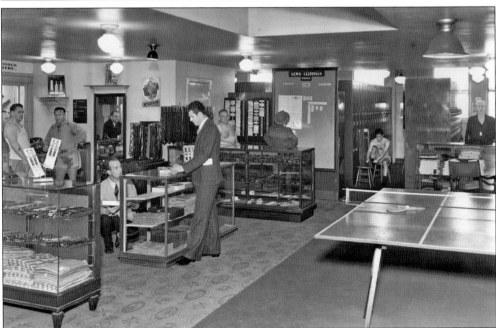

**MEN'S SHOP.** The Men's Shop was on the sixth floor in the main locker room and featured athletic equipment and "up to date haberdashery," which the gentleman in the background at left seems to be in need of. There was also a sports shop for women adjacent to the beauty parlor. (Courtesy MOHAI.)

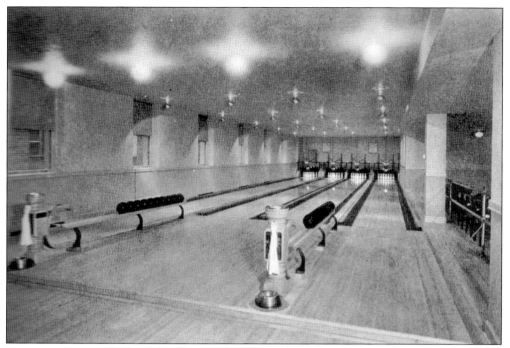

**BOWLING ALLEY.** The bowling alley on the second floor was the site of keen interclub team competitions. The equipment was provided by the Brunswick-Balke-Collender Company of Seattle. (Courtesy MOHAI.)

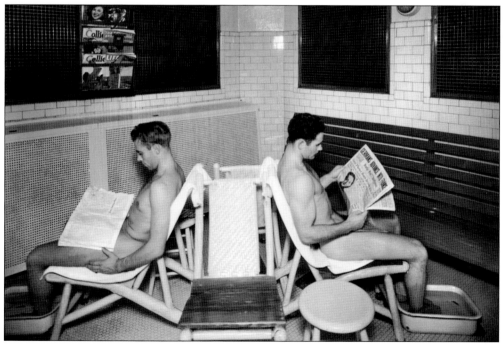

**STEAM BATH.** These two gentlemen are enjoying a sauna in one of the many physical conditioning rooms available at the WAC in the 1940s, which included a "rest room battery shower" and a "Sun-Ray Room." Note the newspaper headline: "Germans Advance into France." (Courtesy MOHAI.)

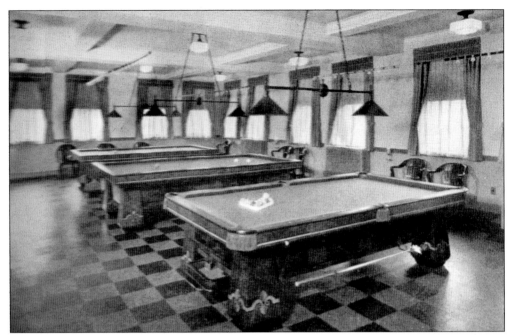

**BILLIARDS.** The Brunswick-Balke-Collender Company of Seattle provided these tables, and their advertisement states, "Men and women attain their greatest alertness of mind and body when engaged in zestful, competitive sports such as billiards and bowling. These fascinating games stimulate friendly rivalry while they encourage concentration, temperate skill and keen judgment." (Courtesy Clinton White.)

**THE GYM.** Adjacent to the physical conditioning rooms, the gym featured handball, squash, and volleyball. The WAC has always been one of the private clubs actively involved in the interclub squash tournaments. However, 1930s members would hardly recognize the modern equipment at the WAC's gym today. (Courtesy Clinton White.)

**THE GRATZERS, SPRING AFFAIR, 2002.** Mr. and Mrs. Louis Gratzer, longtime WAC members, are seen here at a gala dinner and dance. Ruth Marie Gratzer was one of the driving forces behind the Hat Tea, an event that ran quite successfully for 12 years. (Courtesy Loveday Conquest.)

**THE CHIHULY ALCOVE.** Fred Kleinschmidt and Loveday Conquest are seen here in front of the Chihuly Alcove after a dance in the lobby lounge. For many years, the WAC featured a big band in the lobby lounge on Saturday nights. (Courtesy Elizabeth Buzzell McKenzie.)

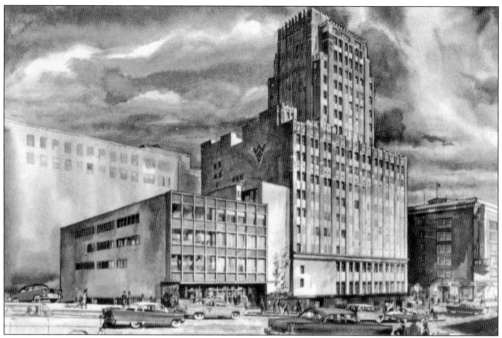

**NEW BUILDING ADDITION.** The modern building addition was constructed in 1954 and remodeled and expanded in 1970. Interestingly, the WAC has no 13th floor, causing some confusion about the building's actual height. (Courtesy UWLSC.)

**HAT TEA.** The highly successful fourth annual Hat Tea on May 16, 1999, featured 12 designers and 4 boutiques, with 11 models from within the club. Winner of "The Most Beautiful Hat," Loveday Conquest models her Jack McGovern feathered number while William Maschmeier, event cochair, shows off his Panama. (Courtesy Loveday Conquest.)

# *Eight*

# THE WOMAN'S CENTURY CLUB

The Woman's Century Club, founded in July 1891, was one of the first clubs of its kind in the city of Seattle.

The club was founded by Carrie Chapman Catt, an internationally known suffragette and worker for world peace. Some of Seattle's most prominent women, many of whom were leaders in the Washington state suffrage movement, were among its charter members. The Woman's Century Club was named by Carrie Chapman Catt because she believed the 20th century would be the century of the woman, and she would take her rightful place in society.

The first meeting was held at the home of Julia E. Kennedy (the first woman to be superintendent of public schools) on July 31, 1891, and presided over by the woman who would become the club's first president, Carrie Chapman Catt.

The intention was to organize a club where women could meet and study the classics along with working in their community to help those less fortunate. Each member was expected to present a paper yearly on an important topic of the day.

Within the club, there were departments that were chaired and served on by the members. Art, drama, American home, literature, and travel were just some of the departments covered. They also taught those who were studying for citizenship, sponsored and paid part of the salary of the first librarian in Seattle for one year, and in 1900 helped found what would become the Martha Washington School for girls.

In the beginning, the women met in the Yesler Mansion library. After a fire in the mansion in 1901, the club met at the General Federation of Women's Clubs offices and in private homes. On October 13, 1925, they moved into their beautiful new clubhouse, designed by architect Pierce Horrocks and built at a cost of $60,000.

The women now had a place to meet, conduct business, and have their social affairs and musical programs. Membership was limited to 600, and there was almost always a waiting list to join. A daughters club was formed in the 1920s patterned after the WAC and called the Woman's Century Club Juniors.

The club is still active today, and while the membership is smaller, it has lost none of the passion of its original founders. Giving a yearly scholarship and working in the community are still priorities for its members.

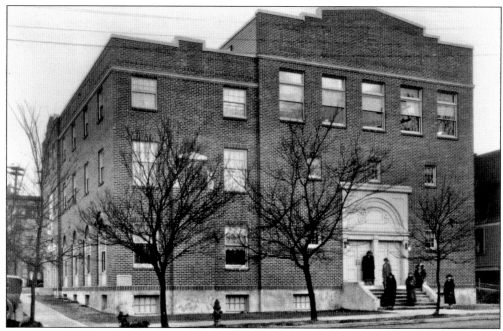

**THE CLUBHOUSE.** The clubhouse was built on the corner of Harvard Avenue and East Roy Street on Capital Hill in 1925. After many years of meeting in various places, the ladies' dream of their own building was finally realized. One of the ways money was raised for the building was by selling life memberships to current members. (Courtesy MOHAI.)

**CARRIE CLINTON LANE.** Carrie Clinton Lane was born on February 9, 1859, in Ripon, Wisconsin. She attended Iowa State Agricultural College in 1877. While working her first two years to make ends meet, she washed dishes for 9¢ an hour and worked in the library. (Courtesy Wisconsin State Historical Society.)

**CARRIE CHAPMAN CATT.** This picture is of Carrie Chapman Catt in later years. She would become the president of the National American Woman Suffrage Association from 1900 to 1903 and from 1915 to 1920, at the height of the women's suffrage movement. Carrie Chapman Catt was a protégé of Susan B. Anthony, an internationally known speaker on women's suffrage, and lived to see women get the vote. She also organized the National League of Woman Voters in 1919. (Courtesy Celeste Smith.)

**E. INEZ DENNY.** E. Inez Denny (1853–1918), the daughter of Seattle pioneer David Denny, was a painter and member of the Woman's Century Club. Some of her paintings can be seen today hanging in the Museum of History and Industry in Seattle, Washington. (Courtesy MOHAI.)

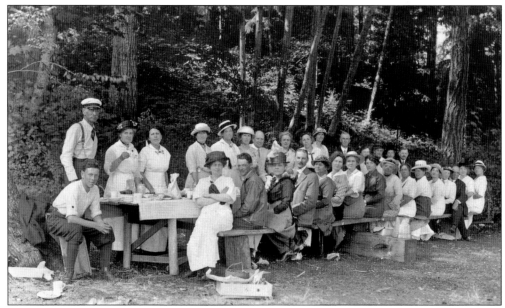

**Picnic.** This photograph of a summer picnic celebrating the birthday of the Woman's Century Club was believed to have been taken sometime around 1910. A birthday celebration is still held today in July or August to honor the founding of the club in 1891. (Courtesy UWLSC.)

VOTES for WOMEN

Women vote on equal terms with men at this date in 25 of the world's nations.
Carrie Chapman Catt

June 12, 1923.

**Original Note.** This rare note written by Carrie Chapman Catt was regarding the progress of women's suffrage in 1923. (Courtesy Celeste Smith.)

110

**FOUNDING MEMBERS.** This photograph of members of the Woman's Century Club, possibly of the early founding members, shows them enjoying a summer afternoon in the early 1900s. (Courtesy UWLSC.)

**SEATTLE REMEMBERS FIGHTER**

* * *　　* * *　　* * *　　* * *

*Suffragists Regret Mrs. Catt's Retirement*

T. 1/26/32

THEN

SIGN THE PLEDGE TONIGHT

NOW

The photograph of Mrs. Catt, taken more than thirty years ago, is the property of Mrs. Dwight Corey, 1466 Orange Place, and was given her late mother-in-law, Mrs. J. Dwight Corey, by Mrs. Catt, a friend of many years. The recent photograph was taken

**CARRIE CHAPMAN CATT'S RETIREMENT.** This *Seattle Times* article, written on January 26, 1932, describes Catt's retirement at the age of 73 from the National Conference on the Cause and Cure of War. The article goes on to tell of how fashionably dressed she always was and of her great energy for her causes. (Courtesy UWLSC.)

**MEMBERS OF THE WOMAN'S CENTURY CLUB IN 1928.** The members are in costume putting on one of the numerous plays they staged in the clubhouse theater. (Courtesy MOHAI.)

**BERTHA K. LANDES.** Bertha K. Landes was the only female mayor of Seattle and was a past president of the Woman's Century Club. She is seen here getting ready to start off the first electric locomotive pulling the transcontinental train into Seattle. (Courtesy Celeste Smith.)

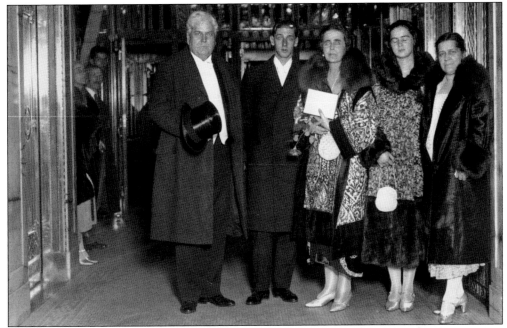

**Mayor Landes With Queen Marie of Romania, 1926.** From left to right are Seattle businessman Sam Hill, Queen Marie's son Prince Nicholas, Queen Marie, her daughter Princess Illeana, and Mayor Landes at the Smith Tower building. Queen Marie helped Sam Hill establish his art museum at Maryhill, Washington. Sam Hill, railroad magnate, was a member of the University Club. (Courtesy MOHAI.)

**Bertha Knight Landes.** Bertha Knight Landes was president of the Woman's Century Club from 1918 to 1920, president of the Seattle Federation of Women's Clubs from 1920 to 1922, and mayor of Seattle from 1926 to 1928. She was the first and only female mayor of Seattle. (Courtesy Woman's Century Club.)

113

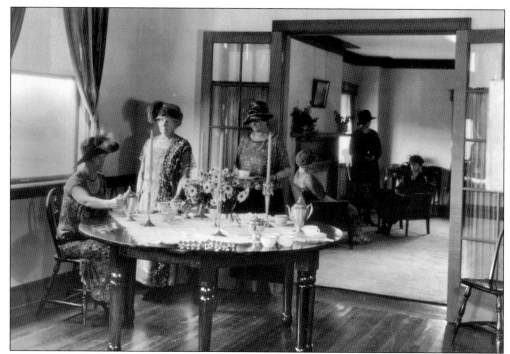

**TEA IN THE CENTURY CLUB.** This picture shows Woman's Century Club members enjoying tea in a second-floor meeting room about 1926. (Courtesy MOHAI.)

**THEATER IN THE CENTURY CLUB BUILDING, C. 1925.** In the 1920s, membership was limited to 600. During general meetings, the board was seated on the stage with the membership comfortably seated in the audience. (Courtesy MOHAI.)

**MRS. CARL J. SMITH (MARY JANE), 1869–1948.** Mary Jane Smith was a life member of the club, joining in 1905. In 1910, she was elected president of the Progressive Thought Club–General Federation of Women's Clubs (GFWC) of Seattle. She was also the grandmother of past president Celeste Louise Smith. Mary Jane Smith was the wife of a prominent Seattle judge, who was one of the charter members of the Arctic Club. (Courtesy Celeste Smith.)

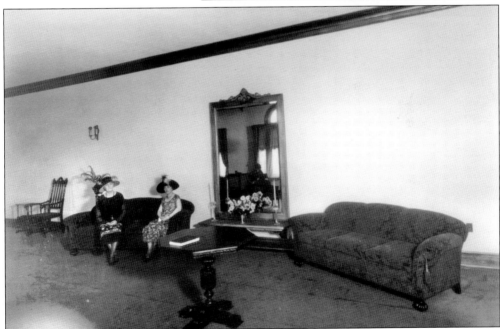

**TWO MEMBERS ENJOYING AN AFTERNOON AT THE WOMAN'S CENTURY CLUB, 1925.** Two unidentified ladies are seen here enjoying a piano recital. The building was sold in 1968 and now houses the Harvard Exit Theater; however, members still meet in the lobby today for lunch, meetings, and programs much as they did in the early 1920s. (Courtesy MOHAI.)

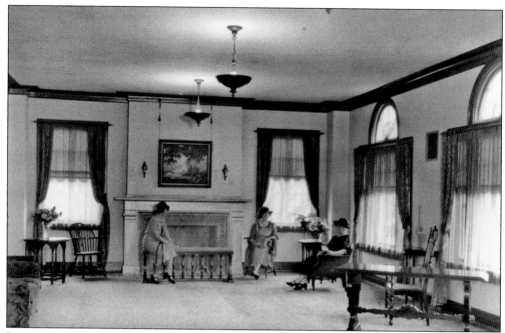

LOBBY OF THE WOMAN'S CENTURY CLUB, 1925. Many of the furnishings in the photograph are still in use today. The club was a place where women could meet and enjoy a cup of tea as well as work on a community project, such as social service projects involving teaching those in the community who wanted to get their U.S. citizenship. (Courtesy MOHAI.)

HARVARD AVENUE ENTRANCE. The Harvard Avenue entrance leads directly into the theater. The building was used for many dramatic and musical presentations, including a reception held there honoring Amelia Earhart on one of her trips to Seattle in the 1920s. (Courtesy MOHAI.)

# Nine

# THE WOMEN'S UNIVERSITY CLUB

The city of Seattle was flourishing in 1914. On May 6 of that year, the first meeting of the Women's University Club took place. The meeting was held in the Henry Building downtown; with 276 women signing the charter and the first board of trustees being chosen, they elected Edith Backus their first president.

Mrs. LeRoy Backus (Edith); a prominent Seattle matron, had the vision of a club in downtown Seattle where women could go to enjoy hearing speakers of the day such as Carrie Chapman Catt, Samuel Hill, Jean Picard, and many other notables speaking on varied subjects. Along with lectures, there were classes in painting, foreign language, and book reviews conducted by club members.

Parties and luncheons were held at the club, and soon it became a cultural center for the college-educated women of Seattle. Edith Backus herself was a graduate of Columbia University.

The first clubhouse was a one-story building located next to the College Club. The opening took place on September 10, 1914. At that time, there was the suggestion of a door being installed for wives of College Club members to lunch and have tea at the Women's University Club; however, this was rejected by the male members of the College Club.

In 1922, the club was evicted from their Fifth Avenue address because of the construction of a hotel in its place. While this was very disappointing, the women saw it as an opportunity for a much grander multipurpose building housing a ballroom, library, and a residence for women of like backgrounds—a place where they could find not only a home but friendships that would last a lifetime.

The money was raised by selling bonds, and the building was built at Sixth Avenue and Spring Street. The club selected the architectural firm of Albertson and Champney to build on the site. By this time, the club numbered nearly 600 members.

The Depression saw a drop in membership, and again with World War II. It would take all the strength they could muster to survive those lean years. The women met their challenges and have been successful in continuing on in their grand tradition.

Today the club thrives and is continually welcoming new members into the long-standing traditions of years gone by while keeping current and looking ahead to its future. The year 2014 will mark the club's 100th anniversary.

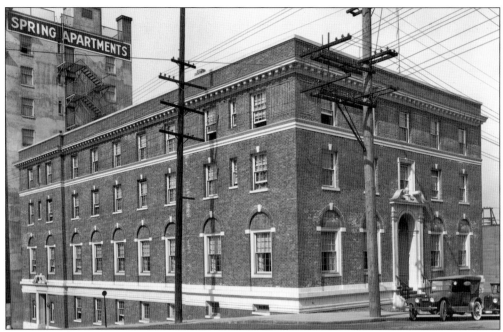

**A New Home.** In 1921, with more than 600 members, the ladies moved into their new clubhouse. The new building was large and elegant with 30 bedrooms. The building also houses a ballroom with 17-foot ceilings. In 1961, an addition was made to the building, including a large dining room and modern kitchen. (Courtesy Women's University Club.)

**Edith Boetzkes Backus.** Born in New York in 1871, Edith Backus grew up in Germany, returning to the United States at the age of 16. She attended Columbia University and graduated in 1898. Her career included being head of the language department at Broadway High School. Upon her marriage to LeRoy M. Backus, she retired from teaching to raise a family. (Courtesy WUC.)

**PRES. EDITH BACKUS.** Mrs. Backus was a leader in Seattle society; she also founded the Seattle Day Nursery and was married to Harvard graduate LeRoy Backus. LeRoy Backus was a prominent Seattle attorney and real estate investor. Edith died August 31, 1935, at the age of 64 after a courageous two-year battle with breast cancer. (Courtesy WUC.)

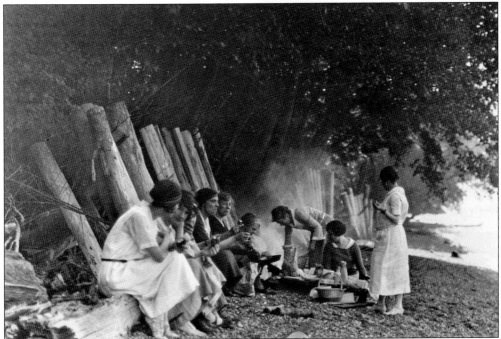

**AN AFTERNOON SOJOURN—SEATTLE 1928.** Ladies of the club are seen here enjoying an afternoon picnic on a Seattle beach. There were many close friendships formed at the club, and women often went on day trips together. (Courtesy UWLSC.)

**PAST PRESIDENT MARIE MCVAY SUMNER.**
Mrs. Henry W. Sumner (Marie McVay)
was president of the Women's University
Club in 1919. (Courtesy WUC.)

**PAST PRESIDENT.** Mrs. Alvah Lemuel (Laura
Whipple Carr) was president of the Women's
University Club in 1921. (Courtesy WUC.)

**STARTING THE JUNIORS CLUB.** Mrs. Gordon T. Shaw (Fredericka Sully) was president in 1937; she was a graduate of the University of Washington and the mother of five daughters. She also formed a junior group in 1937 consisting of younger members and young married women. She felt it was the duty of every feminine leader and club woman to be well dressed. Her husband, Gordon Shaw, was a president of the Arctic Club in the 1940s. (Courtesy WUC.)

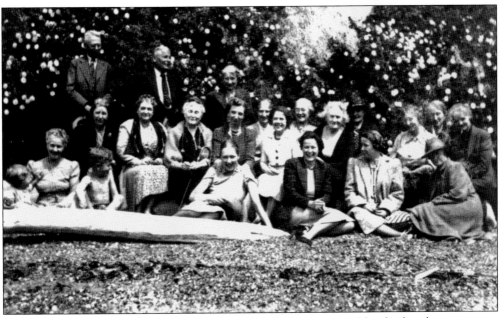

**LOVELY DAY ON VASHON.** Women's University Club Bible Literature Class bridge players are seen here on a *c.* 1935 outing to Vashon Island. (Courtesy WUC.)

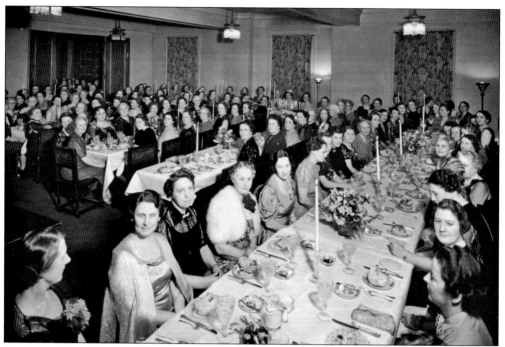

**THE FIRST LADY COMES TO DINNER.** This Speakers Dinner at the Women's University Club on March 27, 1939, was in honor of First Lady Eleanor Roosevelt. The dinner was open to members and their spouse or escort only. The photograph was taken by Walters Studio. (Courtesy WUC.)

**MEMBER GENEROSITY.** This antique white porcelain stove is located in the main dining room. The dining room and kitchen were part of the 1961 addition. The stove is 8.5 feet tall; it is of the neoclassic period around 1770-1780. An identical stove is located in the Museum of Decorative Arts in Vienna, Austria. It was a gift from Mrs. Calvin Hill. (Courtesy Celeste Smith.)

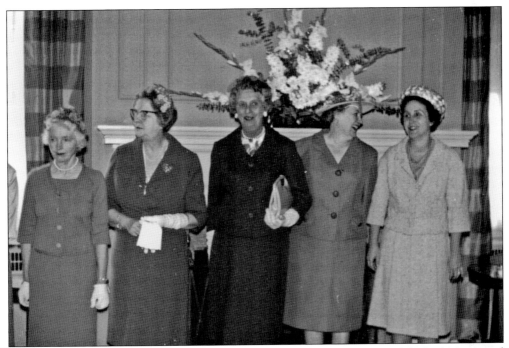

LUNCHEON GUESTS. This Club Birthday Party occurred on February 11, 1964. Ladies pictured are, from left to right, Virginia Woodruff (president in 1979), Louise Schnatterly (president in 1977), and unidentified friends. (Courtesy WUC.)

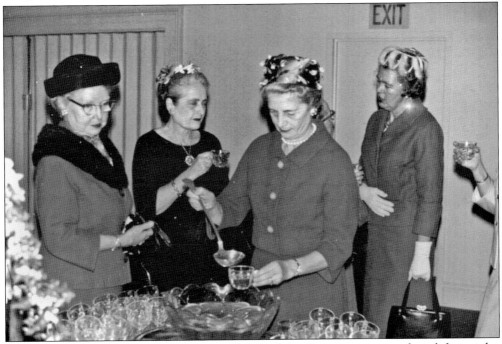

CELEBRATING 50 YEARS. Seen here in a Club Birthday Party picture are, from left to right, members Helen Skahill, Adelle Maxwell (president in 1955), and two unidentified ladies. (Courtesy WUC.)

**Past President.** Mrs. Irving Stanton (Agnes Wright Smith) was the president in 1946. Mrs. Stanton graduated at the age of 20 from the University of Colorado, Boulder, with a degree in engineering. She was the first woman on the faculty of the University of Colorado to teach engineering. (Courtesy WUC.)

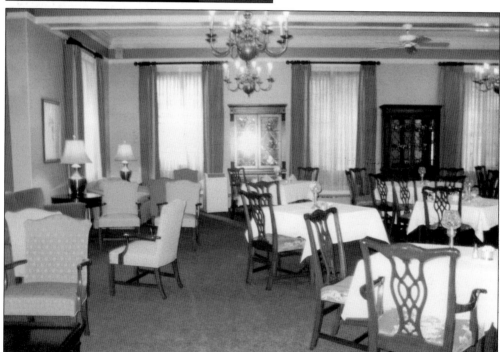

**Elegantly Appointed.** This was the original dining room, now known as the Gold Room. The room remains a warm and inviting atmosphere frequently enjoyed by members. (Courtesy Celeste Smith.)

**WELLESLEY LIBRARY.** A quiet and peaceful library was planned for in the original architectural plans in 1922. There is a lending library members may use, and a committee searches for books on an ongoing basis, keeping a steady stream of good literature flowing through the club. (Courtesy Celeste Smith.)

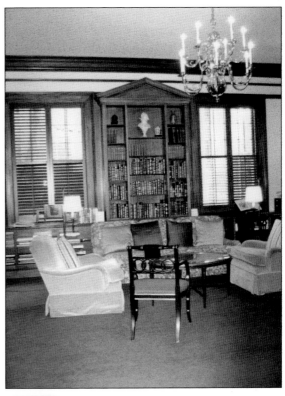

**THE DRAWING ROOM.** This room, with its grand piano and beautifully appointed furnishings, is the meeting place for all occasions. Much attention has been paid to making this room pleasing to the eye. (Courtesy Celeste Smith.)

**HOLIDAY CELEBRATIONS.** This is an invitation to a Christmas celebration in 1992. There is always a full calendar of events, drawing in members with their families to celebrate together as they have done for decades. Strong bonds are built between members, who not only celebrate together but work to improve the club and their community. (Courtesy WUC.)

*December 9, 1992*

*Family Christmas*

*5:30 p.m. in the Gold Room with Santa*
*Dinner 6:30 to 7:30*

*December 10, 1992*

*Adult Family Christmas*

*5:30 Pianist in the Gold Room*
*Dinner 6:30 to 7:30*

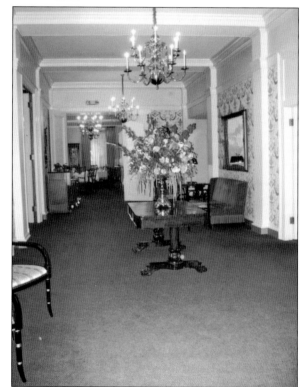

**THE FOYER.** During club events, this entrance hall is used as a gathering place for members to socialize and enjoy a cocktail before luncheon and dinner events. (Courtesy Celeste Smith.)

**A Gift.** This elegant Carr-era marble bust of Proserpine was created by Hiram Powers around 1850 and was purchased by LeRoy and Edith Backus while in Italy. LeRoy Backus gave it to the club in memory of his wife, Edith Boetzkes Backus, club founder and first president. (Courtesy Celeste Smith.)

**Past President.** Mrs. John Petersen (Lailla) was president in 2000 and led the club during the time of the earthquake on January 9. (Courtesy WUC.)

ACROSS AMERICA, PEOPLE ARE DISCOVERING
SOMETHING WONDERFUL. THEIR HERITAGE.

Arcadia Publishing is the leading local history publisher in the United States. With more than 5,000 titles in print and hundreds of new titles released every year, Arcadia has extensive specialized experience chronicling the history of communities and celebrating America's hidden stories, bringing to life the people, places, and events from the past. To discover the history of other communities across the nation, please visit:

# www.arcadiapublishing.com

Customized search tools allow you to find regional history books about the town where you grew up, the cities where your friends and family live, the town where your parents met, or even that retirement spot you've been dreaming about.